PARANORMAL
NORFOLK

PARANORMAL
NORFOLK

FRANK MEERES

AMBERLEY

First published 2010

Amberley Publishing Plc
Cirencester Road, Chalford,
Stroud, Gloucestershire, GL6 8PE

www.amberleybooks.com

British Library Cataloguing in Publication Data.
A catalogue record for this book is available from the British Library.

ISBN 978 1 84868 471 3

Typesetting and Origination by Amberley Publishing.
Printed in Great Britain.

CONTENTS

INTRODUCTION

NORWICH AND THE MYTH OF VAMPIRES

Vampires today are an endless source of fascination and the subject of very many books and films. Few people know of the key role Norwich has played in the saga: the first book written in English about a vampire was by Dr John Polidori, who practised as a doctor in Norwich for several years, before becoming personal physician to the poet Lord Byron in 1816, with whom he travelled throughout Europe, and under whose inspiration he wrote his ground-breaking novel.

Some books and internet sources say that he was in Norwich after his time with Byron, but archive evidence shows that it was before: he is frequently mentioned in the journal of another Norwich doctor, John Green Crosse, as a dining companion and a fellow chess player in 1815. These doctors were sophisticated men, familiar with London and Paris society. Crosse is very sarcastic about a grand Sessions Ball held in Norwich in 1815: 'It struck me as being a sort of market for stale as well as fresh goods. I took up this notion of it from seeing so many mothers leading their bare-necked daughters about with them... Affairs went on dully and the market was certainly overstocked.' Is it too much to assume that Polidori had such dances in mind when he set the opening scene of *The Vampyre* in a ballroom, although he has transposed the scene to London:

'It happened that in the midst of the dissipations attendant upon a London winter, there appeared at the various parties of the leaders of the town a nobleman, more remarkable for his singularities, than his rank. He gazed upon the mirth around him, as if he could not participate therein. Apparently, the light laughter of the fair only attracted his attention, that he might by a look quell it, and throw fear into those breasts where thoughtlessness reigned. Those who felt this sensation of awe, could not explain whence it arose: some attributed it to the dead grey eye, which, fixing upon the object's face, did not seem to penetrate, and at one glance to pierce through to the inward workings of the heart; but fell upon the cheek with a leaden ray that weighed upon the skin it could not pass. His peculiarities caused him to be invited to every house; all wished to see him, and those who had been accustomed to violent excitement, and now felt the weight of ennui, were pleased at having something in their presence capable of engaging their attention. In spite of the deadly hue of his face,

which never gained a warmer tint, either from the blush of modesty, or from the strong emotion of passion, though its form and outline were beautiful, many of the female hunters after notoriety attempted to win his attentions, and gain, at least, some marks of what they might term affection.'

The main action takes place in the Mediterranean, where the drama reaches its climax: 'But what was his horror, when the light of the torches once more burst upon him, to perceive the airy form of his fair conductress brought in a lifeless corse. He shut his eyes, hoping that it was but a vision arising from his disturbed imagination; but he again saw the same form, when he unclosed them, stretched by his side. There was no colour upon her cheek, not even upon her lip; yet there was a stillness about her face that seemed almost as attaching as the life that once dwelt there: upon her neck and breast was blood, and upon her throat were the marks of teeth having opened the vein: to this the men pointed, crying, simultaneously struck with horror, "A Vampyre! A Vampyre!"'

This may seem cliché-ridden today but that is only because Polidori's themes have been copied so many times since. His novel was first published as in a magazine in 1819 and soon after as a book. It gave rise to an enormous number of copycat stories, poems and even operas, and was a direct inspiration for Bram Stoker's more famous *Dracula*.

Polidori died in London in 1821. Many buildings that he would have frequented in Norwich survive: the cathedral spire rising eerily though mist, the Castle, then a grim prison, on its dark mound, the old Norfolk and Norwich Hospital (now apartments) and the Assembly Rooms and St Andrew's Hall, where the 'grand' balls were held. Did they provide inspiration for his book and through it to one of the most enduring forms of paranormal fantasy over two centuries?

CHAPTER ONE

BLACK SHUCK AND OTHER GIANT DOGS

The most famous 'ghost' in Norfolk is not that of any person but that of a dog – BLACK SHUCK. Clive Sheppard told the story in *Norfolk Fair* in 1974:

All over East Anglia stories of Demon Dogs predominate in local folk-lore. These Hell-Hounds, generally called either Shuck or Black Shuck (the word shuck being derived from the Anglo-Saxon scucca meaning a devil or demon) are normally associated with death, either of the beholder or of someone close to them. This belief is expressed in such sayings as 'The Black Dog is at his heels', meaning that the person is dying. The different stories concerning Black Shuck agree on some points. He is almost always described as haunting a lonely stretch of road, loping along it in a manner described as a silent lazy trot. In fact, local language has assimilated the adjective 'shuck trot' to adequately describe this stealthy movement.

He often heralds his imminent arrival with an appallingly hideous howl which has been said to drive men insane and to reduce them to burbling imbeciles. In Norfolk it is reported that he has been seen all along the Northern coast road from Hunstanton to Cromer. The favourite local explanation of this is that one day a fishing boat sank and a few days later two bodies were found washed up on the beach. These bodies were found a few miles apart and so the respective vicars were informed. Each elected to have the body found on his particular parish's soil buried in the local graveyard. This was duly done but the two men were not the only creatures involved in the catastrophe. A large black dog belonging to one of the drowned men managed to swim ashore, and being uncertain which of the two graves was that of his master he still wanders between the two, condemned to ceaseless searching.

Of course this explanation makes a good tale, but the 'Demon Dog' is generally accepted to be a folk memory of legends brought here by the Vikings who settled in East Anglia. A noteworthy comparison can here be made between Black Shuck and the large black dogs guarding copper, silver and gold coins in 'The Tinder-box' by Hans Christian Andersen. Shuck is occasionally associated with treasure as he is at Clopton Hall, Stowmarket in Suffolk, where he appears in order to guard a hoard of gold. The similarity between Shuck and the Danish writer Andersen's dogs seems

A typical north Norfolk lane: watch out for Black Shuck!

proof of the origin of Shuck as a Danish introduction since Danish folk-lore includes these hideous beasts.

Shuck's appearance is very varied; he is normally described as being the size of a calf with a rough shaggy coat. The size and number of his eyes seems to cause confusion. He is said either to have one large plate-sized eye or more often two saucer-sized ones. Sometimes the unfortunate Shuck is described as devoid of any head at all, though I would put this down to pure exaggeration on the part of the people who have recounted the story through many generations. If Shuck really is headless no one has yet given a reason for it.

Shuck seems to be an unhappy beast, for he is said to weep luminous green or red fire, this ties up with his habit of leaping over graveyard walls and then searching among gravestones before disappearing in a cloud of smoke.

Even to this day may people still hold a strong belief in the reality of Black Shuck, and walking through the small winding lanes and long lonely coast roads of East Anglia at dusk, their apprehension may be readily appreciated. There is a lane in Overstrand called Shuck's Lane because he has appeared there so often. The long road or causeway

along the west bank of the river Yare from Southtown to Gorleston has been a haunt since ancient times of footpads – and of ghosts. The ghost was the devil himself in the form of an enormous black dog, known here as Old Scarfe, clearly a variant name for Black Shuck.

The MONSTER DOG has a long history in East Anglia. *Roberts' Norwich Almanac* of 1933 provides a modern translation of a broadside printed three and a half centuries earlier:

Sunday being August 4th 1577, to the amazing and singular astonishment of the present beholders, and absent hearers, at a certain town called Bungay, not past ten miles distant from the city of Norwich, there fell from heaven an exceeding great and terrible tempest, sudden and violent between nine o'clock in the morning and ten of the day aforesaid. This tempest beginning with a rain, which fell with a wonderful force with no less violence than abundance, which made the storm so much more extreme and terrible.

The tempest was not simply of rain, but also of lightning and thunder, the flash of the one whereof was so rare and vehement, and the roaring noise of the other so forcible and violent, that it made not only people perplexed in mind and at their wits end, but ministered such strange and unaccustomed cause of fear to be conceived, that dumb creatures with the horror of that which fortuned, were exceedingly disquieted, and senseless things void of all life and feeling, shook and trembled.

There were assembled at the same season, to hear divine service and common prayer, according to order, in the parish church of the said town of Bungay, the people thereabouts inhabiting, who were witnesses of the strangeness the rareness and suddenness of the storm, consisting of rain violently falling, fearful flashes of lightning and terrible cracks of thunder, which came with such unwonted force and power, that to the perceiving of the people, at the time and in the place above named, assembled the church did as it were, quake and stagger, which struck into the hearts of those that were present, such a sore and sudden fear, that they were in a manner robbed of their right wits.

Immediately hereupon, there appeared in a most horrible similitude and likeness to the congregation then and there present, a dog as they might discern it, of a black colour; at the sight whereof, together with the fearful flashes of fire which then were seen, moved such admiration in the minds of the assembly, that they thought doomsday was already come.

This black dog, or the devil in such a likeness, running all along down the body of the church with great swiftness, and incredible haste, among the people, in a visible form and shape, passed between two persons, as they were kneeling upon their knees, and occupied in prayer as it seemed, wrung the necks of them both at one instant clean backward.

There was at the same time another wonder wrought: for the same black dog, still continuing and remaining in one and the self-same shape, passing by another man in the congregation in the church, gave him such a grip on the back, that therewith he was presently drawn together and shrunk up, as it were a piece of leather scorched in a hot fire, or a mouth of a purse or bag drawn together with a string.

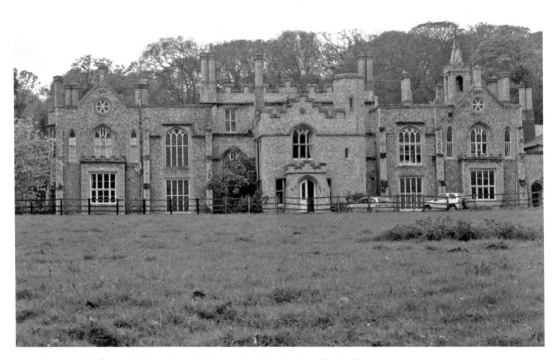

Cromer Hall, probable origin of Conan Doyle's Baskerville Hall

The dog then went out at the porch leaving sundry marks of his talons scratched in the stone thereof.

This hound from hell is known to history as the Black Dog of Bungay rather than as Old Shuck, but the stories all come from a common stream of local tradition. As someone writing as 'Lek' in the *East Anglian Magazine* in 1947 tells us, 'Always he appears in the form of a great shaggy black dog, sometimes with two gleaming saucer-like eyes; sometimes a 'Cyclops'; sometimes without a head, but always with the body of a black hound. To meet him in daylight is a fearsome experience, but should you see him at night death is the most likely outcome of the encounter. Even if you do not die on the spot, such is his evil power that your chances of survival beyond the end of the year are slight indeed.'

Shuck is probably the origin of one of fiction's most famous dogs, the Hound of the Baskervilles in the novel of that name, written by Arthur Conan Doyle. Doyle was in Cromer in 1897 and 1901, staying both times at the Royal Links Hotel. It was here that he and his collaborator, Fletcher Robinson, dreamed up the plot of the book. Max

Stone monster on the Cromer Hall gatepost

Pemberton, editor of *Cassell's Magazine*, recalled telling Robinson about Shuck: 'I told my friends of a certain Jimmy Farman, a Norfolk marshman, who swore that there was a phantom dog somewhere on the marshes near St Olives and that his bitch had met the brute more than once and had been terrified by it. 'A great black dog, it were,' Jimmy said, 'and the eyes of n was like railway lamps. He crossed by path down there by the far dyke and the old bitch a'most went mad wi' fear. Now surely that bitch saw a' summat I didn't see'.

Robinson was from Devonshire and when Doyle heard about Shuck on his 1901 visit to Cromer, told him that there were similar legends among farmers on the fringes of Dartmoor and the two men began building up the plot while in the hotel: the inspiration for Baskerville Hall itself could well have been the nearby Cromer Hall, then occupied by Margaret Bond-Cabbell. Her late husband's family came from Buckfastleigh on the southern edge of Dartmoor, so that the links between the two areas are very close.

Record Office sources have a little to add. An unfinished note among the Blickling Hall archives refers to a haunting by a black dog, but does not say if this is to be identified with Shuck. They also inform us that in the Breckland area, the dog magically transformed itself into a white rabbit! W. G. Clarke, the greatest writer about the region was an avid collector of tales of the paranormal, many of which are recorded among the collection of his work at the Record Office. He tells us that: 'One of the most peculiar beliefs relates to the 'White Rabbit', a marvellous creature which witnesses of unimpeachable veracity assert at one time haunted Thetford Warren. So far as is known it has not been seen for a decade at least. Forty years ago this supernatural visitant often appeared on the School Plains and Brandon Road. The details of the aspect of this remarkable creature correspond with those of a similar legend at Egloshayle village in the valley of the Camel, Cornwall. There the pretty long-eared rabbit with pink eyes would look on any passer by, but woe betide any man who tried to harm it. A boastful visitor one night attempted to shoot it, but was found dead, with a barrel of the gun discharged and the contents buried in his body. Both beliefs are probably derived from the Norse spectral hound of Odin, personified as 'Black Shuck' in some parts of Norfolk. It is remarkable that in two places so far removed as Egloshayle and Thetford the hound should have been altered to a rabbit.'

Shuck is not just a creature of the past: he has been seen several times in the last hundred years. In 1947, F. W. Kent of Rushall wrote to *East Anglian Magazine* that he had seen Shuck about thirty years earlier at Barham Church Lane near Ipswich at about ten at night: he saw a large dog lying in the road which began to follow him and his companion: I struck at it very hard with a stick I was carrying, but the stick went right through it. Had it been an ordinary dog, the blow would have killed it. It bounded away down Barham Church Lane, crossed the main Ipswich-Norwich Road and disappeared through a solid brick wall. That was the last I saw of it'. In 1974, C. W. Skillings wrote to *Norfolk Fair* describing a similar experience when he was twelve years old and staying with his grandparents at the Manor Farm in Aslacton:

'One afternoon during harvest I was taking the empty wagon to the top field to be re-loaded when the horse (a very quiet and reliable one) suddenly shied. I followed the direction of her head and saw what I took to be an extremely large and rough-looking black dog, its appearance frightening and unreal, a large head, jaws open and foaming.

It was loping along at a great rate level with the hedge-row. The horse followed it with her gaze, now calm but, as it approached the end of the meadow, it seemed to go straight through a field gate, and then completely vanished.

I was terrified, but managed to continue up to the harvest field, I told my grandfather what I had seen, but he did not seem unduly interested, and said, 'That was the Old Black Dog of Bungay. There'll be a death in the family, and you will be unlucky all your life.' There were two deaths – my other grandparents very shortly afterwards – and as to the second remark that has proved correct on various occasions during my life. It was an experience I shall never forget. I never went through that meadow again on my own'.

The incident reflects the commonly held view that anyone seeing Shuck will have deaths in their family – or, even more common, that the viewer himself will die within a year. As William A. Dutt wrote in his *Highways and Byways of East Anglia*: 'You will do well to shut your eyes if you hear him howling – shut them even if you are uncertain whether it is the dog fiend or the voice of the wind that you hear…. Scoffers at Black Shuck there have been in plenty; but now and again one of them has come late on a stormy night, with terror written large on his ashen face, and after that night he has scoffed no more.'

Are you a scoffer? Perhaps one day you too will see Shuck loping along a Norfolk lane: if you do, beware!

CHAPTER TWO

COUNTRY GHOSTS

Paranormal activity has been witnessed in every part of the county. The Marshes of Broadland are eerie places as darkness falls, and many legends of the paranormal have arisen in the region. Best-known is probably that of THE LANTERN MAN.

Will o' the Wisp is an eerie light associated with marshes. It is caused by marsh gas, or methane, formed from rotting vegetation, bubbling up and spontaneously catching alight, creating a cold flame. It has always been associated with death. The eerie light is often thought to come from a Lantern Man: his light followed across the marshes will cause the traveller to lose his way, and to drown. The legend is particularly related to one place and one person in Norfolk, Joseph Bexfield of Thurlton, a wherryman who died on the marshes on 11 August 1809.

One evening, he secured his wherry as usual and made his way along a track across the marshes to the White Horse Inn. While drinking, he remembered that he had left on his wherry a parcel he had promised to bring to his wife and decided to return to the boat and fetch it. His fellow-drinkers warned him against doing this, and one told him that Lantern men were 'popping off in hundreds' on the marshes. Ignoring the warnings, he set off in the darkness heading into the marshes. Joseph Bexfield was never seen alive again. His body was found three days later on the banks of the river Yare between Reedham and Breydon. He was buried in Thurlton churchyard, where his tombstone can still be seen, with a carving on it of his wherry. He left a wife and two small children, but death and his henchman the lantern man know no mercy. As Bexfield's tombstone says;

O crule death that would not spare
A father kind and husband dear

The Lantern man normally lures his victim to a death by drowning as in the case of Joseph Bexfield. He is occasionally more direct, knocking a man down and smashing his lantern pieces: the scientific explanation would probably be that the traveller's lantern has itself ignited the marsh gas, causing an explosion and startling the traveller. Another kind of light that can sometimes be seen is fox fire, a soft glow that can be

seen just above the ground: this is caused by a weak light emitted by a luminous fungus and is observed mainly in woodland.

But on the marshes or in the woods, *in the hours of darkness when*, as Sherlock Holmes once said, *evil is exalted*, who can be sure...

The nearest stretch of water to Thurlton today is the New Cut running south and east towards Lowestoft, but this did not exist in Bexfield's day: he must have moored his wherry on the southern bank of the river Yare not far from Reedham. The same stretch of river is also the scene of a haunting by a Viking boat. The story is that it was here that the Viking king Lodbroc was murdered. The legend states that he was driven ashore here in an open boat. He was given hospitality by the king of East Anglia, Edmund, who greatly admired Lodbroc's skill in hawking. This made the king's own falconer jealous: he slew Lodbroc and buried him in a wood. The tragedy was revealed by Lodbroc's dog who came to Edmund's palace each day to be fed. The falconer was condemned to be put into the boat in which Lodbroc arrived, and to be cast adrift without any food or equipment. According to this legend, the boat drifted back across the North Sea to where its journey had begun. There the falconer falsely told Lodbroc's sons that it was Edmund who had murdered their father. In revenge they came to England, bound Edmund to a tree and killed him. The last part is historical fact: Edmund is the king after whom Bury St Edmunds is named.

Another ghost of the Broads is that of THE HICKLING DRUMMER BOY. Lilly Ducker was the daughter of a Hickling marshman who fell in love with local soldier boy, John Sadler: Lilly's father did not approve. He allowed them to meet, but only on opposite sides of the river! It was an exceptionally cold winter in 1813-4, and Hickling Broad froze solid. Lilly waited to hear John at Swim Coots at the edge of the water. Suddenly she heard the sound of his drum, and then a swish of blades – he had skated across the ice to be with her. The next night, he heard again the sound of the drum and the swishing of skates on the ice – but then there was a loud crack, followed by a splash – and then, silence. Sadler had fallen through the ice and drowned. On a quiet evening, his drumming can still be heard across Hickling Broad.

Three are few bridges in the Broads, and these too often have paranormal associations. One bridge where a ghost appears is that at ACLE. When King James I was on the throne, a local man paid the ultimate price for ill-treating his wife. Josiah Burge was attacked and killed on Acle Bridge by his wife's brother, who escaped the country by ship from Great Yarmouth the next morning. Another man, Jack Ketch, who was known to dislike Burge, was arrested, tried for the murder and then hanged from the bridge – for a crime he did not commit. When the true murderer returned to Norfolk, he was taken to the bridge where he had cut Burge's throat and left him to bleed to death. There he was horrified to see a glowing skeleton – Ketch's ghost avenging his own untimely death. The old bridge at Acle was replaced in about 1930 by the present bridge. However, it is said that every April, a pool of fresh blood still appears on the stonework where Josiah Burge met his end. The public house on the south side of Acle Bridge, appropriately enough called the Bridge, is on the site of yet another violent

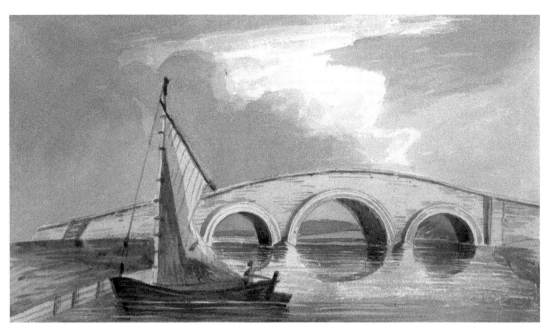

Old Acle Bridge, before its replacement in about 1930

death. In the Middle Ages, before the bridge was built, there was a causeway here running through the marshes and across the river. There was a small monastic house, Weybridge Priory, where the public house now stands, welcoming travellers passing along this lonely road. In 1308, the prior, Humphrey of Weybridge was murdered by one of his fellow monks, a man named Robert. Nothing is known of the background to the case but it can hardly be a surprise if the restless soul of Humphrey still haunts the spot where he lived and died seven hundred years ago.

Further north, POTTER HEIGHAM bridge is another haunted place: every 31 May a flaming coach and horses can be seen driving wildly across the bridge and plunging into the water. The story is that Sir Godfrey Haslitt and Lady Evelyn Carew were married on the day at Norwich Cathedral: Lady Evelyn had entered into a pact with the Devil and, as they were riding home in their carriage after the wedding ceremony, their coachman suddenly turned into the Devil – with fatal results! This story is unusually precise which is its downfall: I have looked into the archives and can confirm that no such people were married in Norwich Cathedral: indeed Carew and Haslitt are not the names of Norfolk families. Somehow the legend has become confused: if you are at the bridge at Potter Heigham on the night of 31 May, stop the coach and ask the couple their true names – if you dare!

North of Broadland lies BACTON WOOD, near North Walsham, and a delightful place for a walk. Beware of getting lost, however: you may not be alone in the darkness of the deep woodland, the ghost of William Suffolk may be behind any tree. William Suffolk was a married man with four children, but started an affair with a neighbour

Mary Beck and had a baby by her. They murdered the child, and later Suffolk killed Mary when she tried to break up with him. He was publicly hanged at Norwich castle in 1797. His body was then brought back to the scene of the crime and mounted on a gibbet beside the road between North Walsham and Bacton: the site is still called Gibbet Piece. Four years later, in June 1803, the remains were taken down and buried nearby.

His confession tells the story:

I, William Suffolk am in the forty six year of my age, was born in the parish of Swael [Swafield] in the county of Norfolk, of poor but honest parents, following the employ of husbandry, until this unhappy thing took place. Accordingly, I became acquainted with Mary Beck, and having gone up and down the grass countries for some years we cohabited together as man and wife. She living near me, we secretly carried on the wicked correspondence together as we had done before, during which time she fell by child with me, tho' unknown to the public; after this we went into the grass countries again, where she was delivered of her infant child, which I confess as a dying man, that she and I was both confederate in the murder of the said child, tho' unknown to the world, therefore as a dying man I confess the justice of my sentence being guilty of the murder.

She having sold three bushels of wheat, upon the return, I requested the money which she refused to give me, telling me it was not her property to give, for she owed it to her brother: I then ask her why she yielded to me the night past, she said she would not yield to me no more, nor be no more in my company. I then stroke her a blow with a cudgel I had in my hand, upon which she fell to the ground; I then repeated the blows three times and left her for dead for what I know: I then took and dragged her cross the horse-road, and left her head in the cart-rut, supposing the people would think she was killed by accident; but herein sin and the Devil deceived me, for no sooner had I done it than I was forced to confess of the murder; But being hardened in sin I told the Justice if I got acquitted of this I had two more to murder, and that was my wife and the Brother of the deceased, but here I hope they will freely forgive me. My Mother has been dead a long time, but I have a poor aged Father now alive, a Wife and four poor little children; herein I earnestly beg that all good people would not cast any reflection on them for my conduct. I die in peace with all mankind. Witness my hand,

William Suffolk

The local newspaper went on to draw the moral: 'The full reflection on the horrid crime of murder, first murder committed with premeditated design is in general the last stage of a long course of wickedness, during which the villain is hardened by constant practices, to such a degree as to stop at nothing to obtain his purposes whatever they are, men of this description tho' they may perhaps commit murder but once in their lives, it is not from a sense of its wickedness, for they are always capable of it, but from a dread of its consequences, so certain is the truth of the old assaying murder cannot be hid, that, they knew committing this last and worst of crimes, that they would sum up

their wickedness and fill the measure of their iniquities. Secondly murder is frequently the sudden result of a sudden impulse of passion, proceeding from provocation, murder committed in such circumstances is generally considered as less wicked, and people are apt to think the murderer rather unfortunate than guilty; especially if his former conduct of life has been without reproach, men have so little guard over their passions, should pray for the assisting grace of God; otherwise they may sometime commit a sin of a most heinous kind, the punishment of which is certain and severe. To conclude murder is the greatest of crimes, as it renders the perpetrator of it the abhorrence of his fellow creature, brings him unpitied to a shameful death, and above all draws down upon his guilty head the heavy displeasure of Almighty God. Let us pray therefore lest we fall into temptation, either from dishonesty or passion, that may lead us to so dreadful a sin'.

According to Neil Storey there was a follow up to the story in the early 1980s. Some children playing at the site of the gibbet found a skeleton on the grass nearby. They ran and told their parents who eventually came to have a look: there was nothing to be seen.

There are ghosts along the north coast too, such as at WELLS, more specifically at Fiddler's Hill. The story is that, once upon a time, a travelling fiddler and his dog came to Wells, and was told that there was an underground passage connecting Bingham priory, not far away, with Walsingham abbey, once a famous Mecca for pilgrims from every part of England. The fiddler declared his attention of exploring the tunnel, and this aroused so much interest that a crowd assembled to see him start. He promised them that he would play his fiddle as he went to show them what progress he was making.

Followed by his faithful dog, he started on his journey and was soon lost to sight in the dark passage. For a time the villagers could hear his gay music, and then, somewhere near the place now known as Fiddler's Hill, the fiddling ceased. They began to grow anxious as the time passed and neither the fiddler nor the dog reappeared, but there was still hope that they might come out at the other end. The hope was vain, and they were never seen again.

This story, too, has a follow up, as explained by Arthur Mee: 'Now it is believed that the solution of the mystery has been discovered. While they were rounding off the corner at Fiddler's Hill in 1933 the workmen came upon the skeletons of a man and a dog. The villagers are convinced that the discovery confirms the legend that has been so persistent down the centuries.'

Further west, the charming village of Burnham Market is haunted too: the BURNHAM GHOSTS arise from a true historic horror that occurred in this peaceful village before Queen Victoria came to the throne of England. A row of cottages in North Street Burnham is known as Murderers' Row or Poisoners' Piece, after the murders of the 1830s – local people say that even today they are hard to let because they are supposed to be haunted.

The Burnham murders took place in 1835: two people died from arsenic poisoning and three people were publicly hanged. The case turns on three couples living in

Burnham – Peter and Mary Taylor, James and Frances Billings and Robert and Catherine Frarey (or Frary). The Taylors and the Billings lived in next door cottages. The people were not young – they were all in their early forties – but they were not exempt from cupid's darts. Peter Taylor and Frances Billings fell in love. Their affair seems to have been well known, several people having seen them together in the streets and yards of Burnham. James also suspected his wife was having an affair, and he had noticed a hole in the wall between their cottages, blocked up with a flint, presumably to allow the two lovers to communicate with each other. Frances thought that if only their respective partners were out of the way, Peter would marry her. She had a close friend, Catherine Frarey, and she too was unhappy with her husband. The two women consulted with witches or cunning women in Burnham, Wells and as far away as Salle, having their futures read in cards, and seeking love potions – and means of getting rid of their husbands!

Eventually they decided to take more direct action. One evening Mary Taylor was given some gruel which had been made for her by Catherine Frarey. She would not drink it because it was so thick, so Catherine made a less thick version and personally brought it to Mary and gave it to her to drink. Mary died: a post-mortem showed that her stomach contained arsenic. Soon after, Robert Frarey also became ill and died. A witness had actually seen Catherine pour into her husband's porter something which looked like powdered lump sugar. His stomach was also found to contain arsenic.

The first enquiry before local magistrates took place at the Hoste Arms in the main street of Burnham. Frances and Peter were committed for the murder of Mary, and Catherine for the murder of her husband Robert.

During the subsequent investigation suspects were held in Walsingham Bridewell before being transferred to Norwich Castle, for the trial at Shire Hall on 7 August 1835. The case against Peter was dropped but both the women were accused of having taken part in both murders. The chemist who had sold them arsenic was soon found, a Burnham man called Nash. Arsenic could only be sold if there was a second person as witness, as demonstrated in several cases in my two books on *Norwich* and *Yarmouth Murders and Misdemeanours*. Nash said that Frances had brought a friend, Jane Dixon with her and purchased two penny-worth of arsenic, saying that she was buying it for a woman called Ann Webster who lived in Creake. At the trial, Ann Webster said she had never asked Frances to buy arsenic for her. Later Frances had sent Catherine to buy arsenic with Hannah Shorten, one of the fortune tellers, telling her she needed it to dispose of rats and mice.

Both women were found guilty. Justice was swift: just three days later, on 10 August they were publicly hanged together outside Norwich Castle in front of a vast crowd of onlookers.

Before her execution, Frances is supposed to have confessed that she had murdered Mary and also that she had tried to poison her own husband, James. However, she claimed that Peter Taylor had not played any part in the murder. Nevertheless, less than three weeks after the execution of the two women, Taylor was arrested and charged with the murder of his wife. His trial took place on 1 April 1836. He defended himself

in a rambling speech, claiming that he and his wife had eaten pork and dumplings on the fatal night: both of them had become ill. However when he produced his sister-in-law, Phoebe Taylor, to say that he had indeed been ill, she was forced to admit under cross examination that she had not actually seen him, it was only what he had told her. Taylor was found guilty and hanged on 23 April: to the last he insisted that he was innocent. Such a tangle of emotions and an innocent man hanged: little wonder that there are thought to be restless spirits in these small cottages in North Street, Burnham Westgate.

W. G. Clarke knew several stories of the paranormal in the Thetford area – one was clearly proved to be faked, which only makes one wonder even more about those for which no rational explanation has ever been found. A landlord in a Thetford inn once fixed a sort of wind harp in the chimney which made blood-curdling noises. People came to hear it – and naturally drank the landlord's ale: the trick was soon exposed.

In another case, however, Clarke himself assures us that the facts are undoubtedly true. A certain lady was sitting in a house at Thetford, sewing. She was facing the door, whilst her companion had her back to it. A lady friend of both was in London at the time. Suddenly the lady, who was facing the door, saw it open, and the figure of this friend in London appear, clad in a different garb to what she had ever seen her before. Jumping up, she said, 'Oh, it's ——', but the door was shut and her companion had heard nothing. Thinking that it must be her imagination she went on sewing, when, about five minutes after, the door again opened and the apparition appeared as before. This time she screamed. A third time did the apparition come, each time the other lady in the room hearing nothing. About twelve months after (it is thought to the day, but no record of the day was kept) the friend in London, who had so strangely appeared, died.

Another collector of tales of the paranormal was Anthony Hamond of Westacre. He also collected many valuable manuscripts about Norfolk, which are now in the Norfolk Record Office – along with his notes on ghost stories! S. R. Kensley of Congham Rectory wrote to Hamond in 1938 concerning a local haunting:

> The following strange experience happened to me many years ago when returning to CONGHAM from Grimston one November evening.
>
> I was walking up the main road, and had just passed the corner drive gate at Congham House where a large oak tree (now removed) overhung the road. At this spot there was a short-cut to Congham over the field and I was on the point of taking the shorter way home when I saw ahead of me, coming from the direction of Little Congham, what appeared to be a tall man dressed in black and wearing a beaver hat. He seemed to be walking quickly, and as he came nearer I saw his face which seemed strangely white. I said, 'Good night', but he made no answer. As he passed me a wave of bitter cold seemed to go through me and I could not move. When I did recover, and turned to look back to the man, there was nothing to be seen. I made for home as fast as I could, and it took me some time to recover from my experience.

The next day I told my gardener about it. He rather surprised me by asking, 'Don't you know who that was? That was old —— who shot himself there more than 30 years ago'. I knew nothing of this story, so what was it I saw?

Now comes a sequel to the story.

Several years after this happened I told the story to a young Grimston man, who ridiculed the whole thing. Some time after I had told him, he called to see me one night and this is his tale. 'You remember', he said, 'telling me of something which happened to you on the Grimston Road. A queer thing happened to me the other night. I was cycling home to Grimston about 11 o'clock when, just as I had turned the corner of the Green Lane, my lights went out and the bike would not move. So I got off, and the lights went on again. I thought this funny, so I tried again and the same thing happened. Then I started to walk and push the bike. I had got up to the corner gate of Congham House, when I thought I would have another try, and I had just got my leg over the bar – when a hand gripped me hard on the shoulder. I called out and looked round – but all I could see was something black.'

A much older story relates to the town of Swaffham in the Middle Ages and demonstrates that the paranormal is not always evil: it can be a force working for good. In 1462, Swaffham pedlar John Chapman had a dream that if he journeyed to London and stood on London Bridge he would meet a man who would tell him some good news. He did so and met a shopkeeper who, without knowing who Chapman was or where he was from, told him that he himself had had a dream that at a place called Swaffham was a pedlar called John Chapman, who had a tree in his garden under which was buried a pot of money. The shopkeeper said he had not been so foolish as to make the journey to check up on his dream. Chapman agreed this would have been foolish, went back to Swaffham, dug under the tree – and found a pot full of money. This was not the end of the story: on the lid of the pot was a Latin inscription saying that underneath lay another 'much richer than I'. Chapman resumed his digging and found a pot with twice as much money inside. Out of the money, John Chapman paid for the building of the north aisle and the tower of Swaffham church. He and his dog can be seen in carvings on a seat within the church.

Norfolk is a country of large houses or Halls, where the gentry have lived for generations, hidden from public view by high walls and tall gates: many of these Halls contain ghosts, most famously Blickling Hall and Raynham Hall. Anne Boleyn was by tradition born and brought up at BLICKLING HALL. She and her brother were executed at Tower Hill in London: local legend says her body was brought home to Norfolk, and her ghost has certainly come back. She can be seen at midnight outside Blickling Hall, riding in a black carriage pulled by headless horses and driven by a headless horseman. She descends from the carriage, dressed in white – and carrying her head in her hands. Anne then glides slowly along the corridors of the Hall, the rustle of her garments being the only indication of her presence. This is supposed to happen every 19 May. As W. A. Dutt says, 'On every anniversary of her execution, Anne revisits the home of her childhood. She rides in a black hearse-like carriage

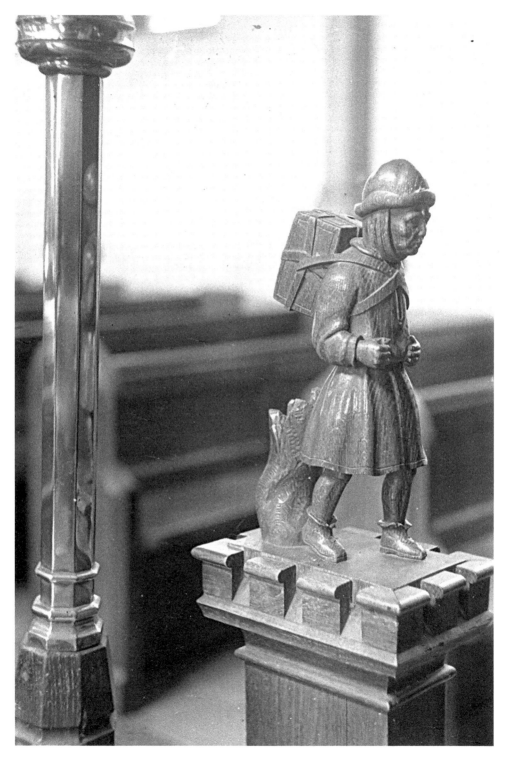

The Swaffham pedlar on a bench end in the parish church

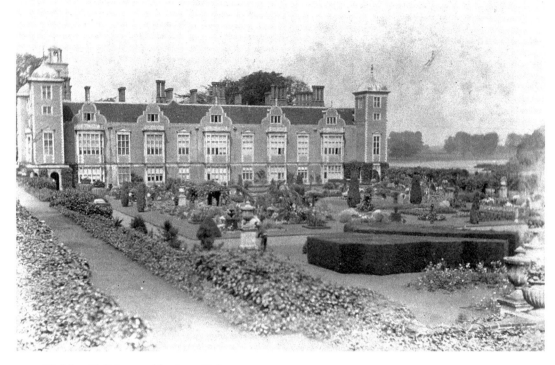

Blickling Hall, haunted by Anne Boleyn

drawn by four headless horses and driven by a headless coachman. She is dressed all in white; and her hands support her severed head, which rests upon her knees. Just before midnight this startling apparition appears and advances slowly up the avenue which leads to the hall. At the hall door it vanishes; but within the old Jacobean mansion there are corridors along which a headless spectre glides. No one heeds it; for the occupants of Blickling Hall have grown accustomed to its visits – even the servants hear without a tremour the rustling of its ghostly garments'.

Her father, Sir Thomas Boleyn, also haunts Norfolk on the same day: he is said to drive a carriage pulled by headless horses and pursued by foul fiends: his fate is to have to journey across twelve (some books say forty) Norfolk bridges – including those at Aylsham, Wroxham and Coltishall – in a single night, and to have to repeat the journey every year for eternity.

The Brown Lady of RAYNHAM HALL is known through a unique photograph taken of her, but is also a well-authenticated haunting. The lady is Dorothy Walpole, who was born in 1686. She was the sister of Robert Walpole, the man who is generally regarded as England's first Prime Minister. The story is that she was betrothed as a child to Charles, later Lord Townsend. He had lived with the family since he was aged thirteen, when Dorothy's father became his guardian. They grew up in each other's

company, and when Charles was twenty-seven and Dorothy was fifteen, he wanted to marry her. Dorothy's father would not allow the match as he feared he would be accused of wanting to gain Townshend's fortune. Charles married another woman, while Dorothy had a love affair with Lord Wharton.

Townsend and Dorothy did finally marry in 1713, after the death of his first wife, but the marriage was not a happy one. He is supposed to have separated her from her children and kept her locked in her apartments in Raynham Hall. She died at the age of forty on 29 March 1726. The death was reported as being from smallpox: however, legend says that she died from a broken heart – or, more dramatically that it was not her heart but her neck that was broken – Dorothy having been pushed down the grand staircase.

The ghost has been seen by several famous visitors over the centuries. King George IV saw the Brown Lady. When he was still Prince of Wales, he stayed at Raynham Hall, in the State Bedroom. He awoke to see the ghost standing at the foot of his bed, 'a little lady all dressed in brown, with dishevelled hair and a face of ashy paleness'. He left the house at once, supposedly saying, 'I will not spend another hour in this accursed house, for tonight I have seen that which I hope to God I never see again'. In 1836, the writer Captain Marryat stayed at the Hall in order to see if it was haunted. He and two men were together in the corridor when a ghostly female figure advanced towards them, carrying a lamp. Marryat recognised her as the lady in a portrait hanging in his room. He was carrying a gun, and he pulled the trigger – the bullet went straight through the figure and was later found buried in a door behind where she had been seen.

Another recorded sighting was probably in 1849, by a Major Loftus. Loftus saw the figure again the following night and observed that she had empty eye-sockets. Some sources say this was actually in 1835, before the Marryat sighting. In 1926, Lady Townshend saw the Brown Lady on the staircase. Apparently she had never heard the stories about a ghost: like Marryat a century earlier, she was sure the figure resembled the portrait of Dorothy Walpole.

What makes this spirit unique is that the ghost was actually photographed in the late afternoon of 19 September 1936. It was taken by Captain Provand and his assistant and is one of the most famous photographs in the world of a ghost! It is unusual in that the ghost was seen before the photograph was taken: usually, the ghost is not seen by the photographer but only shows up when a photograph is developed. The assistant described what had happened: 'Captain Provand took one photograph while I flashed the light. He was focusing for another exposure: I was standing by his side just behind the camera with the flashlight pistol in my hand, looking directly up the staircase. All at once I detected an ethereal veiled form coming slowly down the stairs. Rather excitedly, I called out sharply: 'Quick, quick, there's something'. I pressed the trigger of the flashlight pistol. After the flash and on closing the shutter, Captain Provand removed the focusing cloth from his head and turning to me said: 'What's all the excitement about?' The picture was published in *Country Life* on 16 December 1936.

In January 1937, C. V. C. Herbert, investigations officer for the Society for Psychical Research spoke to the two photographers. He also examined the camera and thought it could well have been a double exposure, not a deliberate falsification but a chance

event. The Lady Townshend who was at Raynham at the time the photograph was taken was a believer in the Brown Lady, but did not believe that the photograph was of her. Whatever you think about the photograph, the Brown Lady may yet haunt Raynham Hall.

The Brown Lady is sometimes confused with a ghost with a similar title, the Grey Lady of HUNSTANTON HALL. She is Armine L'Estrange. In the middle of the eighteenth century, a carpet was presented to the family by the Shah of Persia. Armine swore on her deathbed that she would return to the house if her carpet was removed. Eighty years later, it was cut up and given to the poor by Emmeline L'Estrange, when she married Hamon, the owner of the Hall. She gave the pieces away, but, as she returned to the Hall, she saw a grey face looking at her from a window. That night they were disturbed by footsteps: Hamon went to look, but there was no one there. When she saw a picture of Armine, Emmeline knew at once knew this was the face she had seen at the window. After several days of haunting, the pieces of carpet were collected up and rejoined. Some sources say this was the end of the hauntings, others that they continued. A grey lady has also been seen at the Lodge Hotel, Old Hunstanton – where she has the ability to pass through solid objects.

In another Hall, the ghost has only appeared on a single occasion: the story is told in the *Athenaeum* of January 1880, Augustus Jessopp, clergyman and local historian, was in the library at MANNINGTON HALL, consulting the books: there was a fire and four candles. It was at one in the morning when suddenly he was no longer alone; 'turning my head, there sat the figure of a somewhat large man with his back to the fire, bending slightly over the table and apparently examining the pile of books that I had been at work upon. The man's face was turned away from me, but I saw his closely cut reddish brown hair, his ear and shaven cheek, the eyebrow, the corner of the right eye, the side of the forehead, and the large high cheek-bone. He was dressed in what I can only describe as an ecclesiastical habit of thick corded silk, or some such material, close up to the throat, and a narrow rim or edging about an inch broad, of satin or velvet, serving as a stand-up collar and fitting close to the chin. The right hand, which had first attracted my attention, was clasping, without any great pressure, the left hand; both hands were in perfect repose and the large blue veins of the left hand were conspicuous. I remember thinking that the hand was like the hand of Velasquez' magnificent *Dead Knight* in the National Gallery.

I looked at my visitor for some seconds and was perfectly sure he was not a reality. A thousand thoughts came crowding upon me, but not the feeling of alarm, or even uneasiness: curiosity and a strong interest were uppermost. For an instant I felt eager to make a sketch of my friend and I looked at a tray on my right for a pencil: then I thought: 'Upstairs I have a sketch book, shall I fetch it?' There he sat and I was fascinated: afraid not of his staying, but lest he should go.

Stopping in my writing, I lifted my right hand from the paper, stretched it out to the pile of books and moved the top one. I cannot explain why I did this – my arm passed in front of the figure and it vanished. I was simply disappointed and nothing more. I went on with my writing as if nothing had happened, perhaps for another five minutes, and had actually got to the last few words of what I had determined to extract when the figure appeared again, exactly in the same place and attitude as before. I saw the

hands close to my own; I turned my head to examine him more closely, and I was framing a sentence to address him when I discovered that I did not dare to speak. I was afraid of the sound of my own voice. There he sat and there sat I. I turned my head again to my work and finished writing the two or three words I had had to write.

The paper and my notes are at this moment beside me and exhibit not the slightest tremor or nervousness … having finished my task I shut the book and threw it on the table; it made a slight noise as it fell – the figure vanished.' Jessopp sat for a short time but the figure did not return so he blew out the candles and went to bed.

'And this is the conclusion of the story, but whether hallucination, spectral illusion, or trickery, no one has been able to prove, and as the hero of the tale declines to proffer explanation, theory or inference, the affair continues to be a mystery'.

The ghost has never reappeared in Mannington Hall library.

BRECKLES HALL, and its Park, is another scene of the paranormal. W. H. Hodkinson tells the tale in *East Anglian Magazine*, and it appears earlier in Dutt's *Highways and Byways of East Anglia*. The Hall is the scene of a ghost, seen in the nineteenth century on the occasion of the death of George Mace. Mace was from Watton and the leader of a local gang of poachers. One night he and his gang assembled in darkness in a plantation near Breckles Hall, intending to poach the nearby covers of Lord Walsingham's estates at Merton.

It had been decided that the gang should separate into small parties to lessen the danger of detection and also because such a scheme usually produced better results. Before separating, however, they had all agreed to be back at Breckles Hall before the moon set, so that they could share their spoils.

The evening wore on, and gradually all the poachers drifted back to the meeting place – all, that is except George Mace. Long they waited, their impatience growing. Anxiously they peered first one way then another – listening with practiced ears. But neither sight nor sound was there of George. And all the time the moon was sinking lower and lower.

Suddenly the rumbling of carriage wheels broke the nocturnal silence, and presently a coach with lamps so bright that they lit up the stained glass windows of the Hall was driven up to the front door of the mansion. It stopped. Steps were lowered, the door of the coach was opened and almost immediately slammed to. Then in an instant there was utter darkness as the moon went down and the lamps of the coach went out. The mysterious coach disappeared. In fear and trembling the poachers crept silently home.

Next morning the lifeless body of George Mace was found outside the front door of Breckles Hall – 'not a mark upon his body; not a stain upon his garment; his eyes staring glassily, stiff and cold!'

BROCKDISH HALL is the scene of another story from the Middle Ages, the legend of the Mistletoe Bough: the story of the bride who hid in the chest and was not found again. The tale tells how a new bride, playing a game of hide and seek during her

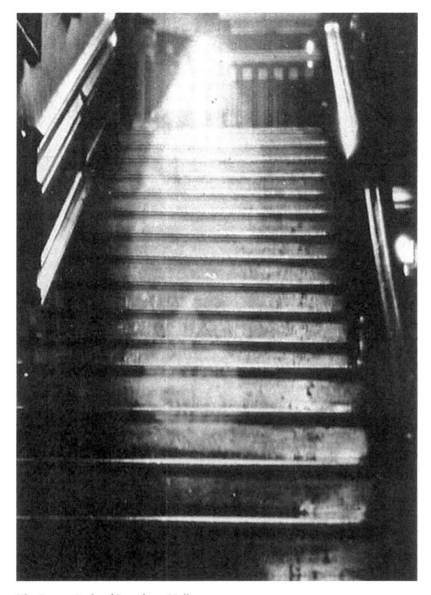

The Brown Lady of Raynham Hall

wedding breakfast, hid in a chest in an attic and was unable to escape. She was not discovered by her family and friends, and suffocated. The body was allegedly found many years later in the locked chest. She was still clasping a sprig of mistletoe with which she had planned to claim a kiss from the lips of her husband.

Sites thought to be built by greater beings than humans are often given the prefix 'Devil's', such as the many ditches and banks in the county, defences against invaders, but often known as Devil's Dykes. One tradition says that the Devil scraped the dyke across Newmarket Heath with his heel – and then scraped his heel at Thetford thus

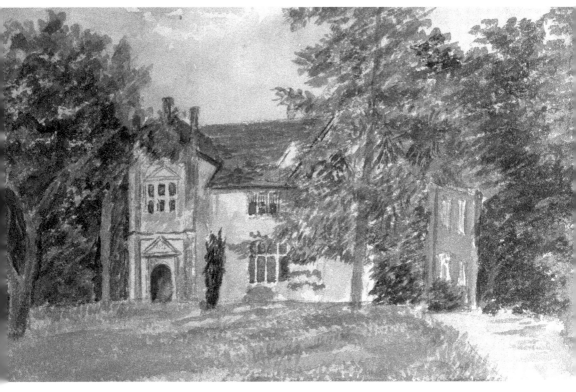

Breckles Hall, where George Mace met his untimely end

creating the castle mound and its surrounding banks. A small hollow in the banks to the north east of the castle mound is known as the devil's hole: if you walk around it seven times at midnight it is said that the Devil will appear. Some of the dyke could be along ley lines, or lines of ancient and mystical power, and there may be others of these in Norfolk marked by ancient sites. Perhaps the most convincing is south of Norwich where three sites are aligned: the hill fort at Tasburgh, the Roman town at Caister Saint Edmund and the henge site at Arminghall. Is this just because they are all near to the river Tas, or are they situated on such a ley line? The matter is discussed in an excellent book by Shirley Toulson, *East Anglia, walking the ley lines and ancient tracks.*

The natural circular lake in Croxton is called the Devil's Punchbowl. Many of the nearby lakes in Breckland known as meres fluctuate being sometimes full of water, sometimes a mere marsh and sometimes completely dry. As this does not directly relate to how much it has been raining in the area, it was seen to be mysterious and perhaps the work of the Devil.

Suicides were often buried at crossroads: such a site could be Marmansgrave near Thetford, although another tradition says that Marman was a gamekeeper murdered by poachers and buried by the roadside.

Gallows Hill above Salthouse

The Devil's Punchbowl, north of Thetford

The bodies of murderers were commonly left to rot on gibbets near the scene of their crime. Gibbet Corner in Upper Sheringham marks the site of a gibbet erected to display the body of the murderer of Thomas Heath in 1635: the name of the murderer is not known, but local tradition says that his broken-hearted mother went out every night in all weathers to mourn her son, his lifeless body decaying as it swung from the gibbet in the cold North Sea wind.

Another such place is Bugge's Grave on the Norwich to Reepham Road near Brand's Lane in Felthorpe. Bugge is supposed to have been a highwayman gibbeted here. Richard Shepheard knew nothing of this when he and a friend had a sighting on the road, which he described in a letter to the *Eastern Daily Press* in June 2010. 'On a still autumnal evening in 1963 a friend and I were cycling out of Norwich on the Reepham road and were approaching the Brand's lane junction at Felthorpe when suddenly we saw a black clad figure riding a white horse at the gallop, seemingly just inside the field to our right, as if heading for Norwich. Even though he appeared to be less than 15 yards away there was no sound of the fall of hooves.... I can only say that the figure was clad in black from head to foot, but I was short-sighted and generally rode without specs. My companion can say that the figure wore a tricorn hat'. The silent horseman was travelling towards Bugge's Grave!

WITCHCRAFT

The presence of people in the community thought to have special powers and links with the Devil is an almost universal belief. Many women and a few men were executed as witches in Norfolk in historic times: I look at the story of the Yarmouth witches in my book on *Yarmouth Murders and Misdemeanours*. Here we look at how the tradition survived, especially in villages, well into the nineteenth and even into the twentieth century.

Where a witch is known to harbour resentment against anyone, or to have expressed an intention of doing him an injury, it is held to be a sure preservative if the party threatened can draw blood from the sorceress, and many a poor old woman has been scarified, from the received opinion that a witch will not 'come to the snatch'. Canon Augustus Jessopp knew a school teacher in the Scarning area in the 1880s who, as a young man, had scratched the arms of an old woman, convinced both that she was a witch and that the only way to counter one of her spells was to draw her blood.

Another example of the survival of this idea came out in a case heard before a bench of Norfolk County magistrates in the 1880s, when a farmer was charged with assaulting the wife of one of the labourers on his farm: it is cited in *Roberts Norwich Almanac* of 1929. The farmer was seen by a member of the Norfolk County Police beating the poor woman with a hedge-stake, and the constable had to drag him away before he could rescue her from his clutches, but not before he had drawn the blood of the unfortunate woman. The farmer's account of the events leading up to this occurrence as given before the magistrates, was that he had forty lambs, on which he had set great store. Out of the sale of the lambs he promised himself to pay his half year's rent and have a bit in hand. But disappointment awaited him. The lambs 'fell off' and did not thrive as formerly, and the farmer was at a loss to account for this. What was the reason? Then one night he dreamt that he was walking in his meadow, and saw his lambs 'frolickin' surprisin' but as he watched the lambs he saw the woman come into the meadow and turn up a sod of grass. To his surprise, from out of the earth there issued a score of black lambs and they had no frolic in them, and they went in among the frolicking lambs. The farmer could bear the vision no longer, but awoke from his nightmare 'that dripping as you might ha' wrung him out'. Next morning,

when the dew was on the grass, the farmer went to the door of the woman's house, and there was a loose sod of grass near to it. The farmer turned it over and there was a large toad! The farmer appealed to the magistrates: was not here a proof 'as sure as you're a-sitting there, gentleman'. Sad to say the magistrates were unconvinced, and they fined the farmer heavily, not wishing to ruin him by a spell in jail. The fine was paid there and then, but the farmer relieved his feeling by assuring the magistrates that they would never make him believe but that 'there ain't none on 'em as wouldn't ha' served that there woman wus'n I did, if he'd been overlooked same as I was.'

It is generally believed that a witch, or wizard, be his size or corpulence what it may, cannot weigh down the church Bible, and many instances might be cited of persons accused of witchcraft applying to the clergyman of the parish to be allowed to prove their innocence by this ordeal. This trial, however, is not considered quite satisfactory, when the suspicion is very strong against the party accused. The only sure criterion by which her guilt or innocence can be satisfactorily obtained is still believed to be by 'swimming'. The actual experiment has ceased to operate; but the practice was once so common that tradition points out several pieces of water as having been customarily used for this purpose, and in particular, in the river Waveney, near Harleston, a deep hole at a bend of the stream is still known by the name of the Witch-Pool. The ghosts of lost souls are said to visit the area still, presumably to avenge their unjust deaths.' Tradition also says that women suspected of being witches were tested by being thrown into Langmere near East Wretham: if they floated they were deemed to be guilty and burned to death.

W. G. Clarke picked up several tales of witchcraft in Breckland in local newspapers. The *Suffolk Times and Mercury* of 4 November 1832 had the headline A NORFOLK SUPERSTITION over this story: 'Last week (writes our Thetford correspondent) information was received at Thetford that a middle-aged woman had been missing at Brandon since October 11th and had been seen at Thetford. Her friends naturally became alarmed about her, and had serious fears as to her safety, and as they could hear nothing about her, they asked that the river between Thetford and Brandon might be dragged. Instead of this, recourse was had to a very curious procedure, in which it appears some people really believe. On Tuesday afternoon the Navigation Superintendent got a boat and rowed down the river, accompanied by a policeman, who was mildly and slowly beating a big drum. It was stated that if they came to any part of the river in which there might be a dead body, a difference in the sound of the drum would be distinctly noticed. The experiment, however, was a failure, and later on it was reported that a person answering to the description of the missing woman was at Elveden. This proved to be correct, and she was ultimately taken home, to the great relief of her friends.'

'An elderly lady of good position' told this story to W. G. Clarke; In a Norfolk village, towards the middle of the eighteenth century, a reputed witch was affronted by a well-to-do farmer of the parish. She cursed him and all that was his, after the manner of witches, and threatened him with punishment. She first inflicted the third plague upon

him [for those unfamiliar with their Bible, this means an affliction with lice]. To be rid of this he tried bath after bath, but to no avail. He then saw the advice of a wise man in the village, who told him to burn his clothes. This was done, and the plague ceased. But the witch had not done with her enemy yet. One evening, as he was driving one of his horses home after a day's work, it was suddenly stricken with sickness, so that it could neither move forward nor backward. The wise man happened to be in an adjoining field, and ran up at the farmer's shout. He told the latter to bleed the horse from a certain vein in the leg, and it would be relieved. But further than this, the blood was to be collected and carried home. At nightfall the farmer was to put this blood on the fire in a frying pan till it bubbled. As the bubbles rose they were to be pricked with some sharp instrument, and during the process, whoever had bewitched the horse would come and scream on the doorstep.

The farmer did as he was told. The horse was relieved according to the wise man's promise, the blood collected, and, when the time came, put on to fry. The blood glugged up, and bubbled with horrid seething blisters, and as each rose it was pricked and burst by a steel-pronged fork. In the midst of this weird rite shrieks and yells shrilled through the farmhouse door. With an oath and a prayer the farmer leapt to his feet and opened the door, while his son continued to prick the rising blood blisters. There, on the step, her features writhed and wrung with anguish, her filthy talons clutching at her grizzled mane, was the old woman who had cursed the horse. She died within a few days, and upon her body were found small black marks, in the midst of rings of dried skin, as if blisters had risen and been pricked and dried upon her.

Clarke also notes a 'curious instance of a superstition which is extremely prevalent in some parts of England, more particularly those where Celtic influence was strongest': it came to light in the hearing of a case at North Walsham Petty Sessions in March 1903. Cubitt Brown, carpenter, of Witton, was charged with being drunk at Honing on 23 January. P. C. Land said he found the defendant at Honing at 11 pm, very drunk and shouting, and not capable of taking care of himself, so he arrested him. Randell Cubitt, son of Mr E. G. Cubitt of Honing Hall, said he saw Brown at about 11 o'clock coming out of the Narrow Pond near the corner of the wood. He was 'roaring' for help and was drunk. It appeared from Brown's statement that he left the Gardener's Arms in Honing, and lost himself (it being a very dark night), finally landing into Mr Cubitt's pond, 200 yards from the road, out of which he was lucky to get back alive. He thought he must have been 'led-willed'. Clarke comments: 'In other parts of the country 'led-willed' is generally termed 'pixy-led', that is, a pixy, or fairy, dominates the will, and leads a person by circuitous routes, absolutely against his own judgement. It is a curious incident, however, that the pixies have more influence on the will of a person after he has been fathoming the depths of a number of pint pots.' Brown was indeed fined for being drunk.

Anthony Hamond also heard tales of witchcraft. He set down the story of Mottie Green of Wells-next-the Sea in 1935: 'I shall put down this story in two bits for it was in two bits that I heard it. Susie Barker was in service with a Mrs Smith of Wells, who

had been one of the Miss Woods of Morston Hall. There was an old woman in Wells by name of Mottie Green who was known to be a witch. The boot boy at Mrs Smith's house was one of a rabble of boys who used to torment the old woman and hammer on her door calling out, 'Mottie Green, Mottie Green, the old witch'. One day she came out and pointing her stick at this boy who was the chief offender she put a spell on him, 'that he would find five pins in his pocket when he got home and that he would die in a fortnight'. The boy, terrified, ran home – only to find when he got there that there were five pins in his pocket as she had said there would be. From that moment he fell ill with a mysterious wasting sickness and gradually died on the fourteenth day. So much for Susie Barker and her side of the story.

Now at this time my [Hamond's] 'great grandmother at Wells', old Philip's wife (nee Louisa Hoare) was living at *Normans*, a pleasant house at Wells, with her daughters. Winifred has since told me that she remembers the boy perfectly well and that when she and her sister Gena used to help run a Sunday school and get candidates for confirmation this boy was outstandingly naughty and troublesome. They implored the parson not to have him confirmed yet but he wanting to show a good quota of candidates to the Bishop would not listen. The boy was confirmed with the rest and 'made monkey faces throughout the whole service.' He then suddenly fell ill and at the same time seemed to show a craving for being read to out of the Bible. When the mother hadn't time to read to him Gena or Winifred used to go and sit with him and read the Bible to him. Nothing else seemed to interest him. He daily grew worse and the readers were kept busy. At last he died and when they buried him he was a mere skeleton he was so wasted away. The uncanny thing about the whole story is that when he grew worse and worse nothing would keep him quiet but that someone should read over and over again the part of the psalm which says 'Though I walk through the Valley of the Shadow of Death, I will fear no Evil.'

There seem to have been 'wise women' in Wells for generations. In 1866, Mr Smith, the landlord of the Railway Hotel, found that items were being stolen from the hotel. He consulted a 'cunning woman', who suspended a bible on a string and made it revolve. As it revolved, they read out the names of possible suspects: when they came to the name Creake it came to a sudden stop. This was enough for Smith who went back to the hotel and gave Creake the sack: however, Creake successfully sued for slander.

Dr Mark Taylor was an eminent student of folklore in the 1920s, and the author of *Magic, Witchcraft, Charms, Cures and Customs in East Anglia*, published in 1928. He put together several files of notes on these subjects: these are now at the Norfolk Record Office. Taylor was especially interested in folk medicine, and saw witchcraft as one branch of this. Many of his stories came from doctors who told him of cases they found on their rounds. One doctor wrote: 'Mrs Scott of Mattishall was overlooked 2 years ago by a farmer. Something cold went through her and her blood curdled. Ever afterwards if she put milk into a bowl it broke, and if she put meat into the oven it came out raw. She cured herself by writing out the Lord's Prayer on a piece of paper, soaking the ink of the paper in water and drinking the water. In spite of being

MAGIC · WITCHCRAFT
CHARM-CURES
and
CUSTOMS
in East Anglia

Collected and Edited

By MARK R. TAYLOR

M.R.C.S., L.R.C.P.

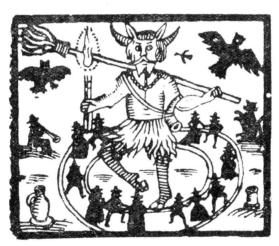

A WITCHES' SABBAT

(All profits accruing to the Editor will be handed over to Medical Charities)

Title page of Mark Taylor's book

cured she committed suicide six months later leaving a message 'G —— done this', G —— being the farmer who had 'looked' at her.

As Mark Taylor wrote, there are good as well as bad powers at work: 'There is to be found in most country villages an elderly person gifted with the power of 'charming' and whose services are more sought after than those of the doctor. She is generally of good repute and by incantations and muttered formulae she destroys the effects of burns and scalds, removing swellings, extracting thorns or stopping bleeding, very rarely taking anything in return. Unlike the witch the charmer's powers are exercised for good, but like her evil-working sister, she leaves her power to whom she will.' One specialism was the curing of warts. A lady wrote to Taylor about this: 'For years there was an old lame man in Heacham named Tom Cooper, who had inherited the gift from his father and grandfather.... The father was said to have cured 155 warts on one man. When Tom Cooper became old and feeble he said he felt the 'power' was leaving him, and he told my sister the secret of the remedy, warning her at the same time, 'if you ever tell it, the power'll leave you and go to the person you tell it to'. Of course she tried it, and she has had some wonderful cures! She frankly owns that she cannot see <u>why</u> the remedy cures.' The sister's aunt was already regarded as a wise woman: 'She could ask for what she liked as people were afraid of what she might do if they denied her. She gathered and sold 'muck', and one day she thought that a farmer who had bought a load from her was piling up his cart to an amount she thought unfair. She 'cast a spell' on his horses and they couldn't move 'not one step' until he had unloaded the cart to the point she thought fair. Then she said, 'G'wun' – and they went.'

Charles Kent, the vicar of Merton, supplied Taylor with stories from his part of Norfolk, delightfully reproducing the dialect:

'I have spoken to several people, good sensible natures and asked them plainly if they still believe in witchcraft. In every instance the answer though guarded has implied belief. 'It can be done'. 'I believe that some bad people have the power to work mischief to others.' 'Yes, old F the planet reader, he don't imitate [pretend], he know a thing or two from the stars.'

Now for a few examples in the neighbourhood:

Mr C: How is your daughter, Mrs B?

Mrs B: Thank you kindly sir, she's better, [then in a mysterious whisper, although no one was within a hundred yards of her]: that woman has been to see her.

Mr C: What woman?

Mrs B: Why old Mrs D to be sure. My gal feared bad and then better, and so we knew it was the old woman; so we sent for her and when she came she never said northen but she looked at her something wonderful and she told my folks afterwards that if she had not been sent for my girl would have burst.

Mr C: But surely you didn't believe such nonsense?

Mrs B: I don't know, she say she can do anybody mischief if they offend her and I don't like to affront such folks as them.

Mr C: But how can a poor old woman do mischief to any one?

Mrs B: [coming very close and whispering] I don't know but she can. My sister told

Ringmere: suspected witches were thrown into this lake

me there was a man at Thompson bought a pig and that died, and he bought another again and gave thirty shillings for it and he had to kill that before he got home and he say he know 'twas the old woman because he had riled her.

In another case Mrs E. F. got the credit for being a witch because her complexion was rather dark and she had a goitre in her neck. Also she was the near neighbour of a man who had been for long ill with diphtheria, whom Master Cobel, the Witch Doctor at Shipdham, had pronounced to be bewitched. It was said of the man suffering from diphtheria: 'he fared to get wus 'stead of better, so his two sisters wrote to Mr Cobel of Shipdham – him that was a Primitive Methodist preacher – and he say, 'You come unbeknown to the man's wife, but when you get home you tell her of it. I can show you her face, but 'tis not worth while, for 'twould make a deal o' strife. The man is bedevilled. I am wholly surprised such a quiet harmless young man for the devil to get hold of. 'Tis a dark woman that done it. He certainly is in bad hands. If he had tried to come here today he would have dropped down dead half-way. The dark woman would not have let him come.' Master Cobel, he gave him an ounce of saltpetre and as soon as he took one dose he felt better, and he kept getting better and was well in

+ Jesus + Christus + Messias + Sother +

Majestas + paraclitus + Salvator noster + A

+ Balthazar + Mathous + Marcus + Lucas +

Jesus Nazarenus rex Judeorum + ea dominica

adversa vicit Leo de tribu Juda Radix David

Christe Eleyson + Kirieleson + per crucis

omne Malignu et item signu salvetur quod

defend me a malis presentibz, preteritis & futu

many sicknesses by pauls handkerchiefe. the eyes

the Leprosy of Naaman by y water of Jordan &

beloved y to save & the beares heereof by thy power

Sacred Names Sigills & Characters herein written

by thy power vertue & might from all enemyes

In nomine patris et filie et Spiritus Sancti Amen

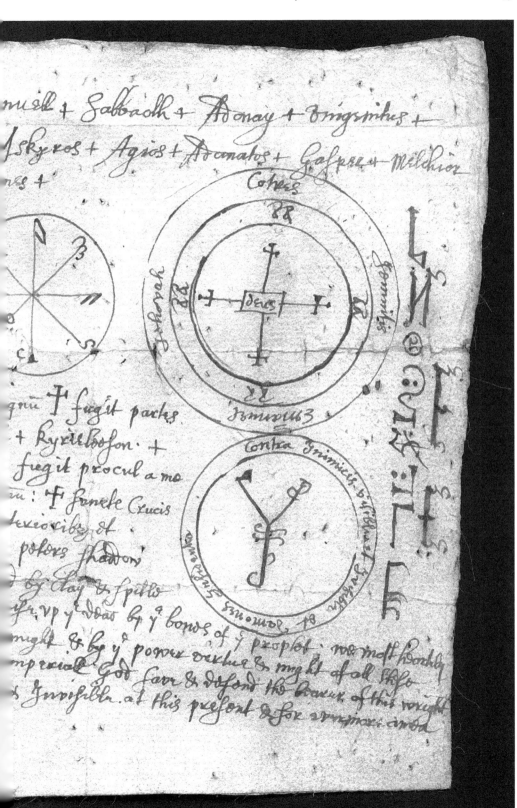

...muell + Sabbaoth + Adonay + Vingentis +

...skyros + Agios + Athanatos + Gaspar + Melchior

...nes +

...qrm + fugit partes
+ kyrieleison. +
fugit procul a me
...m: + Sancte Crucis
...terioribus, et
...polens shadow
+ by Clay & spittle
...fr. vp y̆ dead by y̆ bones of y̆ prophet: me most hornbly
...mprecial God save & defend the bearer of this wright
...s Invisibile. at this present & for evermore amen

Previous spread: Spell to ward off a witch's curse, seventeenth century

Left: Kitty Witch Row in Great Yarmouth

three weeks. Master Cobel say there was a woman in bed ten years and he cured her in one night; and he say if anyone lose any money he can tell who took it. He say he do his work of a night, after other folk have gone to bed. There is a sight of folks go to Master Cobel. The end of Mr Cobel was that he was sent to prison as a rogue and a vagabond, and afterwards wound up in the workhouse.

The above conversation shows the sublime faith which the people of the Breckland villages put in their witch doctor. It is a fact not to be disputed that the man, after partaking an ounce of saltpetre, did begin to mend and was well in three weeks. It is simply an instance of faith, of the power of mind over matter.'

The stories told to Taylor and Hamond show belief in witchcraft in the 1920s and 1930s. In Yarmouth, one of the Rows or narrow lanes in the town is known to this day as Kitty Witch Row. No one knows the meaning of the name: perhaps a witch did live here long ago, possibly one of those women tried and executed in the town in the 1640s. Other people associate the words 'kitty witches' with a group of unruly women: the wives of fishermen, when their husbands were away at sea, would dress in man's clothes, smear their faces in blood, and knock on the door of every house in the Rows demanding money – which they spent on getting completely wasted in the local public houses: there is nothing new about binge drinking!

CHAPTER FOUR

GHOSTS IN CITY AND TOWN

The car park under Norwich Castle Mall shopping centre is a busy place in the daytime, but an eerie space late at night. I was alone there one evening after the shoppers had gone, and there was a real feeling of a presence there: I was very relieved to find my way out. Many unhappy deaths have occurred in and around the Castle, and some are said to have produced ghosts. At the Norfolk Assizes held at Norwich before Mr Justice Grose, Martha Alden was tried for the murder of her husband, Samuel Alden, at Attleborough, on 18 July 1807. While the man was asleep in bed his wife, with a bill-hook, inflicted terrible wounds on his head, face and throat. With the assistance of a girl named Mary Orvice, the prisoner on the 19th deposited the body in a dry ditch in the garden; on the 20th they carried it in a corn sack to the common and 'shot' it into a pond, where it was subsequently discovered. His lordship, in summing up, said that Mary Orvice might have been charged with being accessory to an attempted concealment of murder. The jury found the prisoner guilty, and the judge 'doomed her to death, to be drawn on a hurdle to the place of execution, there to be hanged by the neck, and her body to be dissected.' The execution took place at Norwich on July 31st.

The populace at Attleborough showed their detestation of the crime by destroying the former dwelling house of the prisoner and it was reported that the ghost of Alden 'walked' on Castle Hill. The *Norfolk Chronicle* for 19 December has the story under the headline 'The Castle Spectre': 'One night this week a recruiting sergeant and three other persons having heard an idle report that the ghost of Martha Alden (who was executed last summer for murder) had been seen to 'walk the night' in a white sheet, they resolved to have a peep at the apparition; and sallying forth from a public house, they proceeded up the Castle Hill for that *spirited* purpose; but the spectre not choosing that night to 'revisit thus the glimpses of the moon', the party thought proper to amuse themselves by setting up such hideous yells, as to alarm the neighbourhood, and amongst others the keeper of the castle, who with his attendants rushed out and seized one of these disturbers of the public repose; and he giving information of the names of his companions, they were all taken up and committed to the county gaol, where they remained two days, 'to tell the tales of their prison house'.

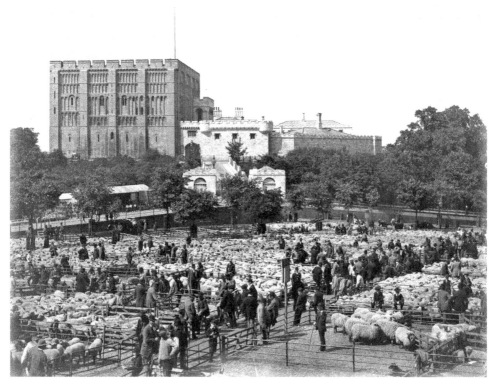

Norwich Castle: public hangings took place between the two lodges at the back of the market

Another ghost on Castle Hill – and seen in the Castle Mall shopping centre – is said to be that of William Cooper, an eighteen-year-old lad who died in agony in the Castle in 1897. He was from Atton's Yard, Norfolk Street, King's Lynn and came into the prison on 30 September. Exactly two weeks later, at noon on 14 October he was found dead in a padded cell. He had been pronounced fit on his arrival and put on the treadmill. After working every day for a week, he complained of feeling unwell. The prison doctor gave him some medicine, and Cooper appeared to improve: he was put back on the wheel. On Wednesday he became restless and troublesome and smashed up his cell: he was placed in the padded cell in the prison provided for such cases and he never left it, dying there on the following day.

An inquest was held at the Castle: William's father, Thomas Cooper, identified the body – and said that his son had never had a day's illness in his life. The Prison Governor was John Bell. He had visited Cooper in the padded cell just an hour before his death. Cooper was lying on his side on the floor: when asked to get up, he remained where he was. Bell was sure he was just sulking and that there was nothing wrong with him, so he left the cell. At five past twelve a warder told Bell that Cooper was dead: he went back to the cell and found Cooper lying in the same position. The foreman of the jury asked why Bell did not take some steps to see whether Cooper was really sick or

just shamming: Bell repeated that when he had spoken to Cooper, he had simply been ignored by him.

One warder said that Cooper had told him the previous evening that he was in pain: it was after this that he had smashed up his own cell, hence his removal to the padded cell. In the morning he had refused to get dressed, so his bedclothes were taken out of the cell: he was still in his own clothes.

The Deputy Medical Officer was Dr Master. He had examined Cooper when he came into the prison and passed him as fit for manual labour. On 10 October, Cooper had told Master that he had a headache and could not work on the wheel. Master examined him again but found nothing wrong, so he was told to go back to work. On the Thursday, Master had examined Cooper in the morning in the padded cell: he was lying on the floor and his clothes and the cell wall were 'besmeared with dirt' (presumably excrement is meant). Master was accompanied by a warden who tried to pull Cooper up from the floor but he slumped back again. Master then examined Cooper once more but found nothing wrong.

It was also Master who conducted the post-mortem on Cooper. An ulcer had perforated his stomach. This must have made working on the treadmill extremely painful, but Master insisted that Cooper had made no complaint. He admitted that had he known Cooper's state of health he would not have put him on the wheel, and also that he was surprised when he made the post-mortem to discover that Cooper had obviously been in so much pain.

Two months later, the case of William Cooper was even raised in Parliament. Mr T. Lough, MP, asked whether the Home Secretary knew about it, whether there had been any similar cases, and whether the Home Secretary was still sanctioning the use of new treadmills in British gaols. The Home Secretary said he had indeed looked into the case and thought that there was no reason to suppose that Cooper had died as a result of working on the treadmill. However, he agreed that unproductive tread-wheels (where the prisoners worked on the wheel just to keep them active, and the energy was not used for any purpose) should be phased out, and that no new tread-wheels were contemplated. Cooper's death was a lonely and painful one, and it is hardly surprising if he haunts the Castle Mall today, but it had at least produced beneficial results for later prisoners.

An instance of a spirit being sighted at the moment of a person's death elsewhere is actually recorded in the city's own archives, having been set down by Henry Cartwright of Norwich in 1791: the events described occurred over a century earlier, however, in 1686. In September of that year an English merchant ship was sailing for England through the Mediterranean. The captain was named Barnaby. On 16 September they landed at the small island of Stromboli. In the words of one of the party: 'We [Barnaby and three friends] went on shore in Captain Barnaby's boat to shoot curlews upon Stromboli and when we had done so we called all our men by us. About half an hour later, *at fourteen minutes after three in the afternoon,* to our great surprise we saw two men come running by us with such swiftness that no living man could run so fast as they did'. They all heard Captain Barnaby say, 'Lord, Bless Me – the foremost is my neighbour!', meaning a man named Mr Booty, who lived next door to him at home in

A public hanging outside Norwich castle

England. He was wearing gray clothing – the figure chasing him was in black. The witness continued, 'Then Captain Barnaby desired us to put it down in our pocket books and take an account of the time, and when we came on board we wrote it in our journals, for we saw them run into the burning mountain: there we heard so great a noise that made us all afraid. We never heard the like before and Captain Barnaby said he was sure it was Booty *running into Hell*.'

The men returned to their ship and set sail for England. They landed at Gravesend on 6 October. The four of them went to Barnaby's house to catch up on the news at home while they had been away. After they had talked for a while, Mrs Barnaby told them that their neighbour had died. They answered that this news was no surprise to them – they had all seen him being harried into the mouth of Hell! Mrs Barnaby went next door to tell Booty's widow what her husband had seen on Stromboli. Mrs Booty did not like the implication that her late husband was a wicked man and took Captain Barnaby to court! Henry Cartwright's narrative continues: 'Mrs Booty arrested Captain Barnaby in a thousand pound action for what he has said of her husband and it came to a trial at the King's Bench. They had Mr Booty's wearing apparel brought into the court and the sexton of the parish and the people that were with him when they died. They swore to the time *within two minutes* that our men swore to, and the very buttons of the coat that were covered with the same gray cloth that the coat was made of, and it appeared to be so' – that is, the same as they had seen him wearing.

Norwich Maddermarket Theatre, haunted by the ghost of a priest

So there we have it. At the very moment that Booty had breathed his last at his house in England, he was seen by four reliable witnesses being hounded by a figure in black into the smouldering mouth of the volcano on Stromboli – and wearing the very same clothes!

Worship by Roman Catholics was forbidden in England at the Reformation and this ban was only lifted in the late eighteenth century. Their first church in Norfolk was in Maddermarket, and a century later the building became the Maddermarket Theatre under the guidance of Nugent Monck: the theatre still flourishes today, but not all its customers are aware that the building is haunted. The story is told in Hilda Wells' book *The Maddermarket Theatre*: 'Almost as soon as the building became a theatre, rumours abounded about the presence of a ghost. Felt usually as an odd, but friendly atmosphere, the ghost has been seen, heard and smelled. The first authentic sighting occurred at a matinee performance in the 1920s.

Like all good prompters, Peter Taylor Smith was dividing his concentration between script and stage when, on a compulsion, he looked to his side where he saw distinctly the figure of a priest not looking at the stage but surveying the audience. The figure suddenly disappeared. The sighting was shared by an audience member unknown to the prompter, confirming all the details of what he had seen. The audience member casually observed that, on a previous visit to the building, he had seen the figure of the priest in the attitude

of prayer. The figure disappeared on that occasion, too. Nugent Monck saw the figure move across the theatre, from the former site of one confessional box to the other.

A stage-manager was once climbing the ladder to the old lighting-box when he became aware that a black-cloaked figure was preceding him up the ladder. On reaching the box, the figure disappeared: there was no other exit. The stage-manager declared that he did not believe in ghosts, but that is what he saw. Nugent Monck remarked; 'I don't believe in ghosts, but I have a great capacity for seeing them'.

The apparition has been heard, too. Working under the stage, Percy Ayres heard somebody walking back and forth on the stage. He called for help, because he needed an extra hand, and when the walking continued and no help arrived, he emerged to find the stage completely deserted.

In his first season as director, Lionel Dunn was making his normal Sunday inspection of the theatre when he found himself assailed very powerfully by the smell of newly-swung incense. When he went up on stage, he was strongly conscious of being watched from the empty auditorium.

After the completion of the first extension, the manifestations stopped, but many people have felt a strange, friendly positive presence in various areas of the theatre. In a lecture, Monck said: 'Most theatres worthy of the name have a ghost. Why not the Maddermarket?'

White Woman Lane also has a paranormal presence, explaining its uncommon name: a woman in white is quite often seen. Once a boy on his early morning paper round saw her cross a field, and suddenly vanish. On another occasion, a lady was driving a pony and trap down the lane when the pony stopped and would not budge. She noticed a mist drifting in across a field: it crossed the track in front of the pony and moved to the right. Once it had gone, the pony trotted on quite happily. The legend is that the ghost was a former owner of the Manor House, and was killed on her wedding day.

Yarmouth Priory School

Moving on to Yarmouth, we must look at Yarmouth Priory School, adjoining the town churchyard. There have been several ghost stories connected with the school for many years. One of the most interesting concerns the Egyptian 'princess', and is told in a booklet produced by the school in connection with a drama performance in 1973. It seems that at one time a nasty smell was noticeable in the Commercial Room. The smell gradually got worse, and it was thought that perhaps a rat had died and was rotting under the floor. Floorboards were ripped up, but no rat was found. The smell persisted, and then someone thought the smell came from a receptacle which, it was said, contained a mummy. It was opened, and it was found that, either through damp or air getting in, rot had taken place, thus causing the smell. It was decided to bury the remains in the churchyard, but when this was about to be carried out, someone, having read up the mummy's history, said that according to ancient custom, one could not bury a mummified princess in daylight, and that the remains should be buried at midnight. Thus, one night at 12 o'clock, shadowy figures were seen approaching the back entrance of the Priory School, and, getting hold of the mummy, proceeded to bury it.

A few weeks went by, and then those at the nearby Vicarage were awakened by knocking on the door. Despite the fact that this was in the middle of the night, the occupants rose and opened the door to find – no one there. The following night exactly the same thing happened, but then the knocking stopped. Workmen taking a short cut through the churchyard however, heard tappings on the church door. Thinking that someone had been locked in the church, they obtained keys and opened the doors. Again there was no sign of any person, so it was assumed the tapping was caused by the branches of a nearby tree, or a piece of wire or string that had been carried by a bird and then caught in a piece of wood or tile. On inspection however, it was found that there was no tree near enough to cause the noise and there certainly was not any wire, rope or string. Once more the Vicarage was visited. The door was opened and once more no one was there. It was felt that this had gone beyond a joke, so the police were informed and a cordon was put around the churchyard. Crowds would stand outside the railings looking for a ghost. Once more tapping was heard from the church, but again with no explanation.

Finally, a smell was noticed in the classroom again. Knowing where to look this time, they re-opened the casket, and lying there were the remains of a leg. In their hurry at dead of night, the burial party had broken off a leg and left it in the casket. The leg soon joined the rest of the remains in their grave, and, strange to relate, there were no more tappings at either the Vicarage or the church. One explanation was that the interred princess could not rest in her grave minus one leg, and so had hopped about on the other hoping to find it, thus causing the apparent tapping.

At the other end of the county, King's Lynn has several stories of the paranormal, including this one collected by Hamond: 'Another authentic ghost story is connected with the Gurney family and the old Bank at Lynn. Old Mrs William Gurney who lived over the Bank and was I believe a Boileau used to be the Dame Bountiful of Lynn and did good works especially among the fishing population. Among these she had her

own particular friends, one being the Skipper of one of the fishing smacks and his family. She was sitting resting on her couch one wild winter afternoon and looking out onto the Tuesday Market Place. It was drizzling an unpleasant kind of rain and the dullness of the day accentuated the sadness of a winter afternoon.

She was turning to her book again when someone came into the room. She did not bother to look up thinking it was the maid come to attend the fire. Suddenly something made her look up and standing at the end of the couch was her friend the skipper. He was dressed in his oilskins and long boots and the water was pouring off him in large puddles onto the floor. He stood looking at her. She raised herself on her elbow starting to get up, saying, 'My dear man what on earth makes you come in here like that' and when she looked up he had gone.

Some say that he said, 'Will you please go and tell my wife that I have been drowned?', but I feel this is more likely to be an embellishment of the story. Anyhow it was proved that he had been drowned at about that time that afternoon.'

CHAPTER FIVE

MODERN 'GHOSTS'

Not all ghosts are spirits from times long ago. Tibenham was one of the many Norfolk villages where there was an airfield in the Second World War. The 445th Bomb Group of the United States Army Air Force flew 280 missions from Tibenham during the war. An echoing voice has been heard across the airfield, barking orders at a crew who left – or died – decades ago. Sometimes the orders are drowned out by the sound of a bomber plane warming up before take-off. A similar story comes from the RAF base at Bircham Newton and appeared in the *Eastern Daily Press* on 12 March 1986 under the headline GHOSTBUSTERS CALLED IN:

> Ghostbusters are investigating three squash playing airmen at Bircham Newton. Psychic investigators Geoff and Susan Cooper fear that the souls of at least three airmen are still trapped at the Bircham Newton airbase where they flew from over forty years ago. 'There is something going on down there,' said Geoff. 'It is nothing horrifying or harmful, but it has been going on for forty odd years!'
>
> Today the station is used by the Construction Industry Training Board, which has an active squash club using two courts built on the base during the First World War. But one court is chillingly colder than its neighbour – and there is no logical reason. Susan said they had concentrated their investigation on this court. Recordings during the night made at the start of this year 'picked up noises that you wouldn't expect to come out of an empty squash court.

While the recorders were in the court they picked up footsteps coming down the stairs – but there was no one there. It would have been necessary to open a door to reach the stairs – the door stayed closed. The recorder picked up a bomber pilot talking to a control tower with the drone of the engines in the background. Suddenly it cut to an eerie silence.

Susan said the haunting began during the war when three squash-mad airmen crashed in their bomber behind Bircham Newton church. 'I think what they are doing now is trying to attract attention to themselves because they need help,' she said. The Harlow-based psychic investigation team concentrates on observing the paranormal. Direct

The airfields of the Second World War have produced several ghosts. James Stewart was one of the many American pilots based at Tibenham

dealings with ghosts are handled by mediums. 'We are in the middle of this investigation,' said Geoff, but he added if they discovered the spectres strolling through the walls at the old RAF station needing help they would bring in ghost experts to release them.

Further proof of the ghosts' existence came in the early seventies when a BBC soundsman went down to play squash on his own. The room was cold and he suddenly spun round to see an airman in full wartime flying gear watching him from the viewing gallery. The soundsman had been there to record a séance held by the famous medium John Sutton. He mentioned the name Wylie, and Susan and Geoff believe this could be the trapped soul of an airman called Wylie who committed suicide on the base during the war.

'They are not harmful,' emphasised Susan. 'I have investigated the haunted house at Borley near Sudbury and there is something there which is very, very aggressive and not very nice. Your instincts tell you to get out'. Her instincts are calm when she visits Bircham Newton. Meanwhile the investigation at Bircham Newton continues with another tape recording visit this month. A spokesman for the CITB said they were used to the ghosts but refused to comment further.'

Glenn Miller playing to American pilots at Tibenham airbase

The story is preserved among papers supporting the Norfolk Sound Archive in the Norfolk Record Office. The same file contains another baffling story of the paranormal, this one taken from the *Eastern Daily Press* of 1 September 1984 under the headline STRANGE GOINGS-ON AT COUNTRY COTTAGE:

'Flowers skirt the walls of the cream-coloured cottage in a blaze of summer colour. But the rural tranquility may be deceptive. Here is a house where things really do go bump in the night. Mysterious footsteps tread the stairs and pace the upper floor of Hamrow Cottage in the village of Whissonsett, near Dereham. Lights turned off at bedtime are burning brightly by morning, household objects are moved and others, such as a broken gold wedding ring, have appeared from nowhere in the middle of a vacuumed bedroom floor.

The strange goings-on at the cottage, believed to date from the late eighteenth or early nineteenth century and once known as Sunnyside, are described by Ann English, who lives there with her husband Peter. They were first alerted when a picture crashed from the wall about nine years ago. And now Mrs English, fifty-six, is appealing to anyone who can shed any light on the mystery to contact her. The baffling events

began around the time of her father's death, when she brought much of his furniture into the house, and have continued on and off ever since. ''About a fortnight ago, I heard a terrific clatter in the bathroom. We have a whisky decanter in there which we use for bubble bath with a heavy stopper in it. That had come out and was rolling around on the window sill. There's no way it could have fallen out because you have to give it a hefty wrench to get it out of the bottle,' she said. Mrs English is convinced something strange is afoot. 'The other day I saw a jug move itself across the window sill and fall on to the floor without making any noise'.

Friends staying at the cottage and the Englishs' collie dog Tim have all heard thuds and bangs, rushed to investigate, only to find no one there. And although Mrs English has searched for logical reasons, such as traffic vibrations or forgetfulness, she has not come up with anything that she believes explains all the happenings. According to Mrs English there is no haunting presence in the house, which has a friendly atmosphere. 'We don't worry about being in the place alone at night, she said'.

Another contemporary ghost is at the Crown public house at Great Ellingham, and here again the presence is not seen as a threatening one. A recent licensee has told of a dog and a child: 'there was an old woman who used to be out in the back storage area, but went no further. Then there was the man who we think was looking for his dog, he's the main one, whom the dogs sensed more than anything. Jasper used to chase him from the kitchen across to the flat, backwards and forwards growling at him and Smudge used to drop the ball at his feet, for him to throw. Thankfully he never did – that really would have been spooky. As for the dog itself that used to live upstairs, only ever had the one encounter with that, when he was next to my bed one night!! I think there was a little boy too, but can't quite remember.'

A very different form of paranormal activity is that of the unidentified flying object. The UFO sighting reports held at the National Archives have recently been opened up to the public. They include a sighting over Norwich in November 1994, made by someone working in the Probation Office in Norwich Prison:

'On Tuesday 15 November I was in the Probation General Office which is located in the administration building known as The Façade. Norwich Prison occupies a position on Mousehold Heath about a hundred feet above the level of the City. The building faces WSW directly towards the Anglican Cathedral.

At approximately 4.15 pm a member of the Support Staff asked me whether I could identify a row of bright lights to the West. Together we looked at a map of the City and concluded that the lights were on the ground in the vicinity of the University. They appeared to be the kind of lights used on a sports ground. My colleague had not noticed them before.

The next day, Wednesday, I was in the office, the time being approximately 7.45 am. I looked once again at the map of the City and having done so went to the window to see whether I could identify where it was that we had seen the lights on the previous day.

The morning was exceptionally bright, the sky clear of cloud. The air temperature was mild, there was little, if any, breeze. There was no haze over the City.

While I was searching the sky-line to the right, or WNW, my eyes were made conscious of a light to my left, two lights in fact.... At first I thought the scene was ordinary enough; the rising sun was already strong and it seemed that I was seeing two hot air balloons, formed from a silvery material. They were identical in size and perfectly round, about ¼ inch to ⅜ inch diameter. They appeared solid, faced directly to the sun. I neither expected to see nor did I see any lessening of reflected light to the edges of the images and so they appeared not to be spherical. Neither of the images showed any movement during the minute or so that I observed them.

I noticed that there were no baskets beneath the balloons and although they appeared to have little altitude I saw no bursts of flame as I should have expected. The brightness of the light coming from the surfaces of the objects made it impossible for me to estimate their distance.

There was neither sight nor sound of aircraft, neither was there, after the images ceased to be visible, any cloud or indication of their presence. The objects appeared to be substantial, to be reflecting light and not emanating it.

Without the objects having moved in relation to the buildings beneath them, after about a minute they both vanished in an instant; they did not diminish in intensity of light or size but vanished from view.

The windows to the office had been cleaned two or three days before the sighting. There was no light on in the office and neither was any of the office equipment switched on. What I saw was not a reflection on the window from within the room... At no time while watching the images or objects did they make any kind of movement.'

Apparent differences in paranormal presences may be just a question of terminology. A medieval chronicle in the Norfolk Record Office records that on 5 December 1274 a dragon was seen in the sky: if he was writing today about the same event, would he not use the term 'unidentified flying object'?

CHAPTER SIX

THE BABES IN THE WOOD

The most well-known story of the paranormal from Norfolk is that of the Babes in the Wood, told to almost every child. It is not always set in its true context however, which is Wayland or Wailing Wood near Watton. It is another very old story: the earliest extant copy is in the British Museum and a ballad version was first published by Thomas Millinton of Norwich in 1595, under the title of *The Children in the Wood, or the Norfolk Gentleman's Last Will and Testament*. There is a good re-telling of the story by Tom Howard in *Norfolk Fair* for January 1970.

Wayland Wood is the place where the court of the hundred of Wayland used to be held. The meeting place, a large oak tree was marked as near the corner of the wood on a map of 1773. It has been claimed that the name goes back to the pre-Christian worship of the god Weland under the sacred tree. Others say that the name comes from the wailing cry of the gulls flying over to Scoulton Mere. But for many people the name Wayland or Wailing Wood comes from its connection with the Babes in the Wood and there is much evidence in favour of the claim that this is the wood where the two children were abandoned. It was much bigger in those days (it used to stretch into Griston, Thompson, Merton and Stow Bedon). The oak under which the helpless babes lay down and died was pointed out for nearly two hundred years, until it was struck for lightning in August 1879. Souvenir hunters came to collect bits and even chips were sold for considerable sums. The stump was chained off and people of the district remember the spot.

The original ballad tells of a gentleman of good account living in Norfolk: he was dying, and his wife was also dying. He had two children, a fine and pretty boy not passing three years old, and a little daughter named Jane. He left them to the care of their uncle, his brother. The boy was to inherit £300 a year when he came of age. The girl would receive two hundred pounds in gold on her wedding day. If they died before coming of age, the uncle would inherit. He promised to take care of them, saying to his brother: 'God never prosper me or mine nor aught else that I have if I do wrong to your children dear, when you are laid in grave'.

The uncle took the children to his own house. Later he determined to be rid of them and hired two ruffians to take them into the wood and kill them, meanwhile telling his

A Victorian illustration of the Babes in the Wood

wife that he was sending them to London to be brought up by a friend. The ruffians and the children walked into the wood together. The children prattled so pleasantly that one of the ruffians decided he could not kill them. The two men quarrelled and fought. The soft-hearted man was killed in the fight, while the watching children quaked with fear. The remaining ruffian led them two miles into the heart of the wood, and then told them to remain there while he went off to find some food. They wandered through the wood hand in hand, finding only a few blackberries to eat. At last, exhausted, they lay down in each other's arms and died. The ballad tells the tale:

> He took the children by the hand
> Tears standing in their eyes
> And bade them straightway follow him
> And look they did not cry;
> And two long miles he led them on
> While they for food complained
> Stay here quoth he, I'll bring you bread
> When I come back again.
>
> These pretty babes, with hand in hand,
> Went wandering up and downe;
> But never more could see the man
> Approaching from the town;
> Their pretty lippes with black-berries
> Were all besmeared and dyed;
> And when they sawe the darksome night,
> They sat them downe and cried.

Supposed residence of the 'wicked uncle' in Griston

> Thus wandered these poor innocents
> Till death did end their grief,
> In one another's arms they died,
> As wanting due relief;
> No burial this pretty pair
> Of any man receives,
> Till Robin Redbreast piously
> Did cover them with leaves.

The wicked uncle came to a bad end, of course. His barns burned down, his crops failed, his cattle died, and his two sons perished on a voyage to Portugal. He eventually died in a debtors' prison. The ruffian was sentenced to death for another crime and before his execution confessed to his part in the death of the babes in the wood.

Tradition has associated the story with the de Grey family of Merton. The wicked uncle is supposed to have lived in Griston Hall – the story is that there used to be a carved mantelpiece in the hall showing two babes, robins and the wicked uncle. At Merton Hall itself there were bedrooms known in the nineteenth century as the Room of the Babes in the Wood, the Room of the Wicked Uncle and the Robin Room.

Wayland, or Wailing, Wood: easy to get lost here!

Edmund de Grey bought Griston Hall in 1541. His grandson Thomas was 7½ years when his father died. He had already been through a form of marriage to a small girl, Elizabeth Drury. If he died, his uncle Robert de Grey would inherit. Four years later, Thomas went to visit his stepmother and died either at the house or his way back: however, her house was nowhere near Wayland Wood but at Baconsthorpe near Holt in North Norfolk. His uncle is supposed to have tried to get hold of the estates and to deny Elizabeth Drury the dower property to which she was entitled: however she certainly did not die in the wood, but lived to have a family of her own. People were prejudiced against the uncle, Robert, because he was a staunch Roman Catholic. He was imprisoned for his faith: however, he did not die in prison, but in Merton Hall: there is a mural tablet to his memory in Merton church.

Most people think that the word Wayland does not derive from the word 'wailing' but that the last part of the word comes from a Norse word for grove, referring to a sacred wood where people worshipped in pre-Christian times. It is an beautiful place and well worth a visit, but perhaps not in the dark: according to W. A. Dutt in his *Highways and Byways of East Anglia*, 'As for the babes, they still wander in Wayland Wood, and on dark and stormy nights you may hear their wailing, which has earned for the wood its local name.'

CHAPTER SEVEN

GHOSTS OF CHURCH
AND MONASTERY

There are many ruined monasteries in Norfolk, and a vast number of churches: a good many have paranormal associations, some of which go back centuries. The monastic house at South Creake has had associations of mystery for almost 500 years. This monastery came to a sudden end in 1506 when the monks here all died of plague within a week. The buildings began to decay, and there were rumours of buried treasure left by the monks. In 1528, a monk from St Benet's Abbey (itself the scene of paranormal events, described in chapter eight), paid John Sharpe to go into the ruins with him in an attempt to find the treasure. Sharpe is described as a necromancer: he 'called to the spirit of the treasure': however, it was never found. This story was taken seriously by no less a man than Ian Fleming, the author of the James Bond books, who adopted a more scientific approach: in 1953, he and a four-man team from the Royal Engineers came to the abbey ruins and spent three days searching for treasure with an electronic metal detector. They failed to find anything, so either there is no treasure – or it is still awaiting discovery!

There are impressive ruins at Binham of the former Benedictine monastery there. The mother of a friend of mine visiting the site for the first time reported that at one particular alcove within the ruins, she felt a sensation of extreme cold. Later, she discovered that one of the monks was supposed to have had hanged himself on that spot many centuries ago. We do know of one man who, according to tradition, suffered a terrible fate at Binham, Alexander de Langley. He was the abbot of another monastery, that at Wymondham, in the thirteenth century. He was driven mad by studying his books too hard, and, in the harsh treatment of the Middle Ages was sent to Binham where he was kept in chains in solitary confinement until he died: he was buried in his chains. It would hardly be a surprise if his ghost haunted the scene of his suffering.

Another ancient legend is that of the Good Sword of Winfarthing. Tradition says that the sword was left in the churchyard at Winfarthing by a thief who sought refuge there. It was found by the monks and placed in a shrine in the church. It acquired remarkable powers in finding stolen goods – and in losing unwanted husbands!

Some ghost stories with an ecclesiastical setting survive in the archives at the Norfolk Record Office, such as one relating to South Lynn, also told in the *Norwich Mercury* for 9 November 1907. A note copied from an old parish account book reads: 'About the year 1825, the Revd J. W. Greaves, then a lad of fourteen or fifteen, having heard divers tales of one of the chambers in the old Vicarage House being haunted, determined, if possible, to find out the cause. He had himself frequently heard rattling noises during the night, which he attributed to rats. He commenced by tapping the walls of the room carefully in order that he might find out any hollow places or secret chamber, such as may be found in very old houses. After some time he came upon a spot in one of the walls of the room which, for several feet, appeared to sound hollow. Then, without assistance, he commenced by driving a hole through the brickwork, and proving it to be hollow beyond he pulled it down and made a considerable opening, and there, to his utter astonishment, he beheld what appeared to be the skeleton of a female, and dangling from her skull were a few pieces of rusty wire, which had evidently once formed a wreath, but now nothing remained but the framework of wire. Beneath was a heap of dust and fragments of what had been a curiously-worked robe, and one very high heeled shoe, in a fair state of preservation.'

One Norfolk vicar actually saw fit to set a ghost story down in his parish register! 'December ye 12th 1706. I, Robert Withers M A, vicar of Gately do insert here a story which I had from undoubted hands, for I have all the moral certainty of the truth of it imaginable.

Mr Grove went to see Mr Shaw on the second of August last. As they sat talking in the evening, says Mr Shaw, 'On the twenty first of last month as I was smoking a pipe and reading in my study between eleven and twelve at night, in comes Mr Naylor (formerly fellow of St John's College in Cambridge, but has been dead these four years). When I saw him I was not much affrighted. I asked him to sit down, which accordingly he did for about two hours and we talked together. I asked him how it fared with him. 'Very well', says he. Were any of our old acquaintances with him? 'No', (at that I was much concerned), 'but Mr Orchard will be with me shortly, and yourself not long after'. As he was going away, I asked him if he would not stay a little longer but he refused. I asked him if he would call again: 'No' – he had but three days leave and he had other business.

The vicar adds: 'Mr Orchard died soon after. Mr Shaw is now dead. He was formerly fellow of St John's, an ingenious good man. I knew him there but at his death he had a college living in Oxfordshire where he saw the apparition'.

The most famous story associated with a church is that of Syderstone parsonage, told in Chapter Ten. It produced a letter in the *Norfolk Chronicle* on 29 June 1833 telling of a similar experience. The writer was John Baker and relates to an event that occurred twenty years earlier when he lived at Reedham parsonage: 'My family consisted of Mrs Baker, myself, and six or seven children, with a governess, three maid servants, a woman who was nurse and her husband (both between thirty and forty years old) we were disturbed by noises nearly similar to those lately heard at Syderstone, and

had I not taken the utmost pains to prevent alarm and to find out the real cause of the outrage, similar excitement would have taken place as at present. The maid servants slept in two beds in a large attic, they were first disturbed by a knocking heard at one side of the room next the floor, this was told to the nurse, through whom it was communicated to me. I determined, as alarm was created, to sit up in the parlour next night, desiring the nurse and her husband to wait till a signal was given from above of the intruder. About eleven being informed the Ghost was at work, I proceeded with the man and his wife to the scene of action: the three girls were all in one bed between terror and mirth, 'laughing in their fear'. Nothing was heard until the candle was put out, presently a slight rapping was heard as before. I immediately decided and said it was a rat, Soon after we heard a noise as if that animal was biting the boards, this confirmed me in my opinion. After waiting two hours it nearly ceased and we retired. Next night it was still more violent and began soon after the servants went to bed. I was again summoned, the same party went again to the room, the noise was from the same place and of the same sort, but louder, the rapping was like the wagging of the tail of a pointer dog against a door, and the scratching like that of a cat against the boards violently – the noise was too loud for a rat, neither was it likely that the creature would chose the time for intrusion when several persons were talking, laughing, and screaming near to it. After waiting about the same time as the night before it ceased and we left the room. I was, I confess, rather 'bewildered'. The following night I was obliged to be from home, but I charged that the affair was not to be spoken of in the village; on my return I learned that the servants were so terrified that they had removed their bed into the nurse's room, and that exactly the same sounds were heard there. It occurred to me that one of the girls must be a ventriloquist. Next night at bedtime I had the one I suspected employed below with the nurse, and sent the other two to bed, nothing was then heard, frequent messages were sent upstairs to learn the state of things in that quarter, but all was quiet: about one, I think, we who had sat up, all went to bed but very soon we were roused, the Ghost had not only been heard in its usual place, but had gone to the side of the bed whence the same noises proceeded; again the servants were removed to the nurse's room. Next night the same happened, with the addition that after knocking and scratching at the bedside something was felt distinctly by the girls to trample over them, the watchers were now increased, the governess taking part in the enquiry. We four placed ourselves on chairs near the feet of the bed, all was quiet as usual till the light was extinguished; immediately on this being done the sounds were heard in different parts of the floor and soon the girls screamed, declaring the Ghost was on the bed. I endeavoured to pacify them. It came again and again; suspecting that one of the servants had put her hands out of the bedclothes whilst the other two were covered over head by the bedclothes, I went downstairs and lighted my dark lanthorn, which I brought up closed, and placing myself as before I had the chamber candle extinguished. We soon heard the noises, and presently the screams gave notice of the rampling on the bed. I turned my lanthorn and distinctly saw the suspected girl's hands applied to the counterpane which covered her terrified partners. This fully satisfied me that the whole was done by this person, she having the power of ventriloquism or conveying sounds to a distance, but as this could not be understood

Above and below: Granite pillar used as a gravestone, Beeston Regis churchyard

by some of my companions, and as the Ghost had frequently made particular noises when I defied it I proposed that the suspected one should be placed in bed between her partners, each holding one of her hands. When I defied the Ghost to come on the bed, it did not come.

Baker sacked the servant: however, he may very well have assumed too much about the events under his own roof: the girl certainly frightened her companions by running her hand over the bedclothes under which they sheltered – but **was** she the cause of the noises that had terrified them in the first place – or was there a spirit at work here in Reedham too?

Within the churchyard at Beeston Regis, once all alone on the cliffs of the north coast but now adjoining a caravan site, is a large rectangular block of granite, over a metre long and half a metre wide: it is the tombstone of local farmer James Reynolds, who died in 1941, and was also used for his wife Ann Elizabeth, who died in 1967. There is a similar stone by the north wall of the churchyard. The story is that the two stones were originally standing on either side of a pathway in the yard of the farmhouse built on the ruins of nearby Beeston priory. James Reynolds would often drive past them in his horse and cart: a hooded grey ghost (one of the former monastic inhabitants?) would hide behind one of the stones and, at sunset, would leap out and try to grab the reins of the horses: it would then vanish, leaving the horses terrified. It was supposed to be Reynolds who ordered the stone be laid on his grave when he died, apparently in an attempt to lay the ghost. There is no granite in Norfolk so someone thought it worthwhile to bring these enormous stones here, but this could have happened at any time between prehistory and the twentieth century: we may never know their true origins, or the reason why Reynolds chose one for his tombstone.

THE GHOSTS OF W. H. COOKE

The best part of working in a Record Office is that one never knows when one may come across something very special. Among my favourite documents are the collections of W. H. Cooke, a serious historian of north-east Norfolk – but also a collector of paranormal stories which he told in his unique style and with his own illustrations. In this chapter, we look at some of the best, beginning at St Benet's Abbey, that lonely former monastery in the marshes near the river Bure.

'Many years ago in the reign of King Henry I there was a young monk of this abbey named Edwin who wanted to follow his own will with an easy conscience. The godly discipline of our Rules were irksome to him and many were the chastisements his refractory conduct brought down upon him. He had to carry the lantern of penance, he was sentenced to prostrations without and he was often whipped and repeatedly imprisoned but all in vain: he remained unhumbled and knew no sense of shame. It was during one of these imprisonments that a pious brother having obtained the permission of the Lord Abbot, visited him for the purpose of trying to move him to a better state of mind. He might as well have tried to move a rock – to all entreaties, warnings, expostulations and arguments he returned but one answer: his own will and pleasure were the only laws he would obey. In despair the good brother turned to leave him but first put in his hands a small relic – a single hair of Saint Benedict and bade him keep it on his person in remembrance of a friend. This touched the right chord and Edwin kept for a friend's sake that which he otherwise would have thrown away as worthless. It was well he did so, not that he appeared any better for it but rather waxed worse and worse until at last he took the fatal step and ran away from the abbey to which his vows bound him. Far he wandered following the dictates of his carnal will – neither fearing God nor regarding man.

It so happened that as he journeyed on footsore and hungry a strange knight mounted on a noble steed overtook him. 'Weary monk, whither goest thou?' said an insinuating voice. 'I go no whither', replied Edwin. 'Then follow me', said the stranger, 'I have need of an esquire and thou by thy manly looks and well knit frame art made for a better life than that of a paltry monk. Thou shalt have thy share of pleasure and a share in many

Creake Abbey: is there buried treasure here?

a noble enterprise – and plentiful wages. Lo: there is thy first guerdon. Edwin gazed at the well-filled purse held toward him and said, 'I will follow thee': as he took the purse he beheld the face of the stranger – it was that of a hideous Dragon!

Edwin dropped the purse and cried out in horror. Then said the fiend triumphantly 'Hah! It is too late. Thou hast taken the guerdon. Thou hast promised to serve me. Thou shalt follow my will for thy will is my will'. He then seized Edwin with an irresistible grasp but at that moment, a sword pierced the armour of the dragon from whence flowed a stream of sparks and a fire. With a howl of pain and rage the Fiend vanished. Almost swooning with terror Edwin saw in front of him clothed in a white tunic and wearing a tall cap issuing out of a coronet and holding a great broadsword. Then he heard a sweet voice saying, 'Those that bear about with them a remembrance of me I remember, but thou must return to the Convent lest worse befall thee.' It was Saint Benedict – the relic had saved him. So Edwin returned to the abbey and became obedient to its rule.

Many years ago the causeway leading from the Abbey to the Hospital of St James witnessed the ghostly appearance of Saint Benedict and the young monk, but in

St Benet's Abbey church. This and the next eight illustrations are all by W. H. Cooke

consequence of an improved system of drainage and the high cultivation of land the apparitions have vanished but in very wet seasons the dim outline of two figures have been seen. Their disappearance is regretted as they were omens of good fortune.'

Cooke has another story about St Benets: 'In common with all orthodox abbeys and priories the abbey of St Benets or rather the fragment remaining is HAUNTED! The apparition is of evil omen. The Shrieking Monk of St Benets is as fearful as Black Shuck the goblin hound of the Norfolk coast as those who have the misfortune to meet either of them will assuredly cease to exist before the year ends.

The scene at St Benets commences with a horrible commotion apparently in the interior of the ruined mill tower. Above the uproar fearful shrieks are heard. During a lull a beam is thrust out over the entrance arch. The shrieks become louder, next the form, apparently that of a monk, is seen suspended at the end of the beam, writhing in the agonies of death. Another dismal groan is heard then a ghastly white light flickers within the Gateway. This concludes the tragedy.

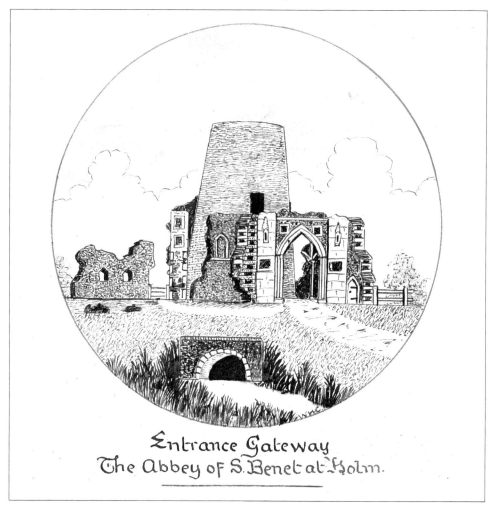

Entrance Gateway
The Abbey of S. Benet at Holm.

The gatehouse at St Benet's where a monk was hanged: it was later converted into a windmill

Some years ago on All Hallows Eve a wherryman on crossing the Marshes from Ludham on his way to his wherry which was moored in the Bure not far away from the old Chequers Inn found himself opposite the abbey gateway at the time an extra special performance was in progress. Petrified with horror he perforce witnessed the fatal closing scene. With a yell of terror he rushed away. Missing his wherry he fell into the river and was drowned.

R. W. A. Dutt in his interesting book *Highways and Byways of East Anglia* thus tells the story of the apparition in the old Norfolk dialect and in the experience of a Norfolk wherryman:

> There was a full mune an yow could see the Mill and Mashes as clear as at nune da. I was a-settin in my cabin wi my mate when all orf a sudden like we heered the rummest kind of screechin and then we see a man a runnin toe-wards ower wherry

Seal of the abbot of St Benet's

as fast as he could put his feet on the ground. When he got a long side I sed, ses I: 'Whatuvver eer yow a hollerin arter?' 'T'wornt me bor', ses he, 'it was a suffin as came out o' the owld gateway. I was a gooin home tu Ludham as I had bin lookin arter my bullocks on the Mashes to see as how they wor all right, when I kinder thowt I heered suffin muvvin about. When I got within 20 yard o' the archway out came the thing a wamblin about an screechin like a stuck pig. My hair stood right up. It was suffin orful.

Whatuvver twas it gav that Ludham chap a funny fright an as he dusent cross them Mashes we made him up a berth in our cabin and took him as far as Wroxham Brudge.

The apparition is believed to be that of Edric the caitiff monk who basely betrayed the Abbey into the hands of William the Norman in order to become Abbot.

The story is well known in Norfolk. William, who did not take to traitors, took over the abbey following Edric's betrayal – and promptly ordered that the treacherous monk be hanged. Coke concludes: 'Even to this day few care to cross these dreary marshes after sunset, much less at midnight when 'the sheeted dead do grin and gibber'. Even when the sun is shining a mysterious shadow seems to hover over this God-forsaken place. An efficient system of drainage and the high cultivation of the land have banished the appearance of St Benedict and the young monk Edwin, but nothing seems to prevent the appearance of *The Shrieking Monk of St Benets.*

Another of Cooke's legends is that of the Ludham Dragon:

'During the time the Bishops of Norwich occupied their Palace at Ludham, the inhabitants were alarmed by the appearance of a hideous monster said to have been a DRAGON. Some said it was a monstrous lizard. This was manifestly wrong as it had wings and was covered with scales. Its formidable mouth was filled with huge teeth. It measured from 12 to 15 feet in length. As it appeared after sunset none dared to leave their homes when it was dark.

It made a burrow which extended from a yard at the back of what is now the Carpenters' Arms in the Street to past the NW angle of the churchyard. Each morning the exit of the burrow was filled with bricks and stones which were thrown out by the Monster at night. One bright sunny afternoon it unexpectedly appeared. As soon as it had got some distance away a courageous parishioner dropped a single large round flint stone into the burrow. After basking in the sun for some time it returned. Not being able to remove the stone it turned away bellowing with rage, and lashing its sides furiously with its tail, scattering its scales in all directions. At last it made its way across the fields in the direction of the Bishop's palace. Turning to the left, it made its way along the Causeway leading to the Abbey gateway. Round and round the ruin it ran, throwing up stones and dirt in its fury. At times it would raise its hideous form against the ruined walls. At length it entered the archway when it was supposed it made its way to the vaults beneath and was seen no more. After a time the burrow was bricked up. Since then nothing has been seen of *The Ludham Dragon.*

Above and below: Two drawings of the Ludham dragon

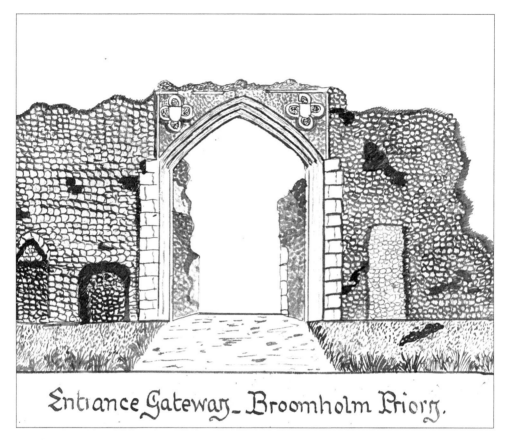

Gatehouse to Bromholme priory in Bacton

Cooke did not just make up his stories, as shown by this article in the *Norfolk Chronicle* over a century earlier (28 September 1782): On Monday the 16th inst, a snake of enormous size was destroyed at Ludham in this county by Jasper Andrews, of that place. It measured five feet eight inches long, was almost three feet in circumference, and had a very long snout: what was remarkable, there were two excrescences on the fore part of the head which very much resembled horns. This creature seldom made its appearance in the daytime but kept concealed in subterranean retreats, several of which have been discovered in the town: one near the tanning office, another in the premises of the Rev Mr Jeffrey, and another in the lands occupied by Mr William Popple, at the Hall'. Several retreats? It sounds as if there was not just one huge horned snake in Ludham but a whole family of them – maybe their descendants are there even today? Something to think over as you walk through this lovely Broadland village.

Cooke also knew a romantic legend relating to Broomholm Priory in the parish of Bacton (more usually spelled Bromholme):

'The young Monk Hubert and the Fair Edith. In medieval times Norfolk possessed so many abbeys and priories that it was called the Holy Land! Their inmates were

supposed to be weary of the world and had bidden adieu to its pomps and vanities and above all to have obliterated every trace of human affection. According to the legend of Broomholm this desirable consummation was not always attained. 'Stone walls do not a prison make', neither do those of a monastery exclude – Love! Then as now old Adam would not and could not make a saint, although he sometime strived to pass as one.

Broomholm was not different to other holy houses and be it remembered many of the monks there were young men. From the account given in the legend it would appear that human nature then was much about the same as it is in our day: a fair face was then able to upset a youth although a monk.

This was the case with young Hubert de Coalville a Cluniac monk of Broomholm. Although a monk he possessed a heart, and that organ, which was supposed to be attuned by ghostly training and stern monastic discipline, was susceptible of human love, an awful sin on the part of a son of Holy Church and which merited the severest punishment.

On a winter's afternoon a furious storm was raging at Bacon. Then – as now – the Beach was crowded with villagers all watching a vessel in distress striving against the fury of the cruel North Sea. A tremendous wave was seen approaching the doomed vessel: when its force was spent the barque had disappeared. Amongst the crowd that day there were several of the grey robed monks of the priory, one of whom was young Hubert de Coalville, a handsome specimen of monkery. As he strolled along the Beach he discovered the apparently lifeless form of a maiden cast ashore by the waves. As the legend informs us:

> He rises from the chilly sand
> The form that cold and lifeless lay,
> Sustains it with a trembling hand
> And wraps it in his mantle gray.

After a while she regained consciousness and gazed on her rescuer. Alas, poor Hubert:

> He whose only oriflamme should be
> The ensanguined cross of Calvary

Imperilled his soul's welfare for a maiden's love, for with both it was a case of love at first sight! Young Hubert, being highly connected – a relative of the founder of the priory:

> With promise of bounteous pay

Had no difficulty in finding suitable apartments for the fair Edith who may be regarded as the Proto-visitor of Bacton! Hubert to give him his due by penance, prayer and fasting did his utmost to obliterate the remembrance of the rescued maiden. We find that:

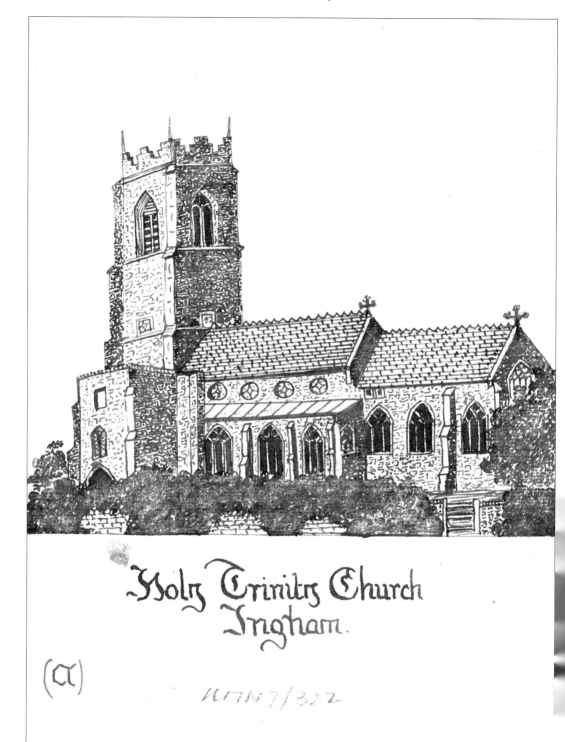

Holy Trinity church, Ingham

Day after day, day after day
Did Hubert and fair Edith stray
Along that smooth and sandy shore.

Precisely as young people do now – a natural and much to be commended practice, except perhaps in the opinion of crusty old bachelors and sour visaged antiquated spinsters to whom 'such goings-on' are gall and wormwood – who complacently observe that they have been providentially preserved from such a course.

But the course of love between Hubert and Edith was the reverse of being smooth. In fact so stormy did it become that langour took the place of strength and despondency that of hope. Poor Edith died pressed closely to poor Hubert's broken heart. Her last words were:

Hubert – dearest Hubert – my request
My last and dying wish would be
That in the last embrace of death
My place may then be next to thee
And by the willows that oershade
The streamlet by the woodland hill
Our dust may be in sadness laid
And then, in death, together still.

Her request was faithfully observed – but how Hubert managed to have the poor girl buried in consecrated ground will always remain an unsolved mystery. It may be that Hubert's relationship to the founder of the Priory cause this uneconomical burial to be winked at by the Prior, it may be that 'filthy lucre' had as much influence with saints and sinners as it has in our day – but as the sequel proves this interment caused complications.

As previously stated, many of the monks of Broomholm were young men. Probably a 'fellow feeling made them wondrous kind'. Anyhow they were not entirely fossilised by the austerities of their profession. Although cognisant of the weakness of their erring brother they did their utmost to soothe his last moments, for we are told:

That round about him watchful stand
The brethren of that holy band.

A vision of Edith cheered the dying monk, and poor broken hearted Hubert passed into the unseen breathing her name. The brethren mindful of poor Hubert's dying request buried him beside Edith by:

The willows that oershade
The streamlet by the woodland hill.

The legend thus concludes:

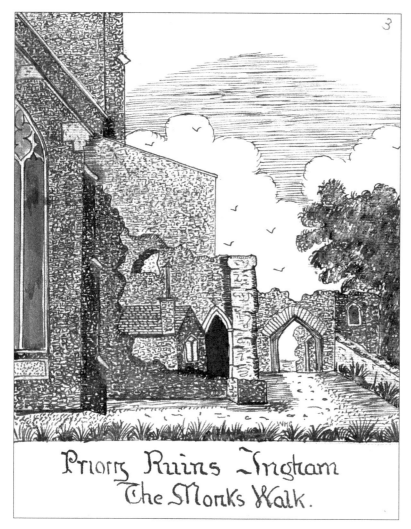

The Monks'
walk, Ingham

Broomholm's Abbey is old and gray
And monks are kneeling the live-long day.
From matins' time till eve.
Many and sweet are the aves they say
And many the souls they shrive.
At midnight the censers were brightly swinging
Softly and sad was the requiem singing
And masses are chanted still
For him they laid in the willow shade
By the stream by the woodland hill.

But after all that had been done for the repose of the young monk's soul neither he nor the ill-fated Edith could rest in their unconsecrated graves. Previous to a storm,

the shade of Hubert would be seen coming out of the now ruined Chapter House wandering through the cloisters. An attempt would be made to enter the Priory Church. With a dismal moan it would pass though the Entrance Gateway toward the sea shore, along what was known as Blood Slat lane because of a sanguinary encounter once took place in it between retainers of the Abbey and a band of marauders whose object was pillage, so fierce was the encounter that blood reached their ankles – hence its name. To reach the beach the mound would have to be passed. Here Edith from her lonely grave would join Hubert – together they would pass on and vanish. After a time they would return, when Hubert would join make his way to the Priory and Edith to her lonely grave.

The apparitions have longed ceased to appear, that of Hubert because of the ruin which overtook the Priory, and that of Edith because of the willows dying and the drying up of the stream by the woodland hill. Those who inspect the ruins of Broomholm – and they are well worthy of a visit – it would do them no harm to ponder over this Legend and should there be any in Holy Orders let them be thankful their Church does not impose such cruel and unnatural restrictions as those which embittered the lives of *The young Monk Hubert And the Fair Edith*.

A final Cooke story is told in a deliberately humorous style:

'The monks' dance: a legend of Ingham Priory. Many years ago, more than a century there was no licensed house in east Norfolk more popular or better conducted than, as it was then called, the Owl in the parish of Ingham, thus named because the crest of the brave old Warrior and statesman Sir Oliver de Ingham was 'ye owle out of ye ivie bush', formerly on the tilting helm at the head of the effigy on his beautiful but shamefully mutilated tomb in the stately chancel of the grand old church of the Holy Trinity on the north side of which are the ruined cloisters of the Priory of Saint Victor. These cloisters were haunted by the shade of monk who in the white robes of his order with the red and blue of Saint victor on his breast, would wander through them at certain seasons of the year, of which Christmas Eve was one.

He would then approach the ruined sacristy where three other monks descending a spiral staircase, still remaining, would join him. The four after solemnly passing through the cloisters three times would pass on to the east side of the chancel and disappear at the entrance to the Squire's Vault immediately beneath the great east window. As they vanished a ghastly light would flicker in the chancel. This concluded the performance.

Many reasons were assigned for the appearance of the four monks but the one unanimously believed in by the good people of Ingham was that very soon after Harry Tudor in 1535 had bundled out, neck and crop, the pious brethren, a parishioner purchased that part of the priory precincts which was set aside as the burial place of the Priory. From it he removed vast quantities of gravel. So avaricious was he that he nearly caused the destruction of the church by undermining it. With the gravel he carted away large quantities of human bones: amongst them were those of the four monks who in haunting the spot resent the indignity offered to their remains and a

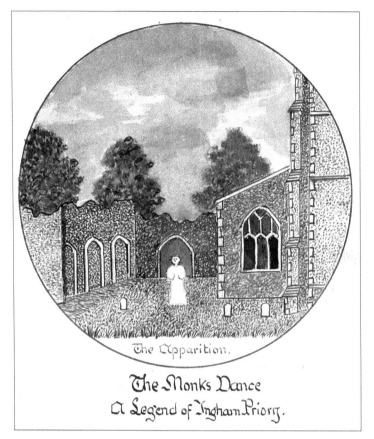

The Apparition.

The Monks Dance
A Legend of Ingham Priory.

The Monks' dance,
Ingham

protest to the sin of disturbing consecrated ground. As we shall hear more about this ghostly quartet we will leave them in the Squire's vault and make our way to the Owl an ideal resting place on a stormy winter's night.

The spacious Kitchen was paved with large stone slabs said by those NOT belonging to the parish to be gravestones reversed stolen from the priory burial place. The old inn was a part of the Priory buildings – all around the old fashioned range which had a fireplace sufficiently large to roast a moderate sized pig were high backed oak seats as black with age as the great beams above them very warm and comfortable. If the Kitchen could thus be commended what shall be said of the Parlour? Its transcendent qualities can best be described by the word – Snug! And snug it was as the bitter east wind howled through the ruined cloisters and when the snow laid thick on the Owl.

At this date in the nation's history the cheerful old matron of the inn was Mistress Elizabeth Dugdale better known to her neighbours and patrons as Betty Duggle, whose partner the late Jonathan Duggle had some twenty years previously been snugly tucked up under the daisies in the churchyard hard by.

On a piercingly cold Christmas Eve the Kitchen and Parlour were filled with guests. In accordance with a long established custom Betsy – at her expense – was handing round to her admiring patrons jorums of steaming Egg Flip! Then the jolly old squire

standing where the Kitchen and Parlour met would call on his friends and neighbours to drink to the health and prosperity of their old friend Betsy. The cheers which followed made the old beams ring. The company would then indulge in harmony – as each one had his own particular song all knew what was coming so that a programme was unnecessary. Finally Mr Peter Pipkin would oblige with The bay of Biscay-O as only Mr Pipkin could.

Next old Jimmy Jubbins would (as usual) relate his experience of an adventure many years ago – in fact when he was only 'a young un' – how, on passing a churchyard not very far from where they were sitting on Christmas Eve on the strength of twelve he saw a hearse with a headless driver and four headless horses stop at the churchyard gate. As Jimmy described the weird scene the company drew closer together and nearer the fire. As he was describing how the phantom hearse disappeared in blue flames and smoke, the outer door of the Owl was violently opened and in staggered old John Dorgs the blacksmith livid, panting and speechless with eyes – Tom Tungate declared – as big as tea saucers!

After Mrs Duggle had administered a supply of Egg Flip supplemented by a glass of extra special brandy – the tongue of poor old Dorgs was unloosed. Taking a seat as far from the outer door as possible, in a whisper he related the awful scene he had witnessed in the churchyard as he passed through it on his way to the Owl. As he came from Farmer Bluggs whose old mare had strayed from the Forge of Mr Borgs that afternoon, he told them he had seen the four monks on the SOUTH side of the church, near the Lady Chapel an event which had never happened before. It was firmly believed by all Ingham people that it was impossible for them to pass beyond the entrance to the Squire's vault at the EAST of the chancel. He next described the Dance of the Four Monks and their horrible screams as they performed their uneconomical exercise. As tongues began to wag – old Jubbons hinted that Dorgs must have been getting a 'a bit forrard'. This the blacksmith indignantly denied declaring that what Mrs Duggle had given him was the first time he had 'wetted his whistle' that evening.

What troubled the company was the appearance of the four monks on the SOUTH side of the church. Of course they were all used to them on the NORTH side but if the Squire's vault at the EAST end failed to keep them within bounds there was no knowing how far they might wander. Or the mischief they might cause. Mrs Duggle chilled as she listened.

In the parlour, Mr Pipkin was of the opinion that a deputation should approach the Vicar and earnestly request him to immediately bring the subject before the Bishop. To this suggestion Mr Puggs the radical baker snorted – Rubbidge! The deputation did approach the Vicar but each time the Reverend gentleman was absent. In the end after a long and anxious discussion both Parlour and Kitchen unanimously agreed that – something must be done!

A young fisherman pluckily offered to accompany Dorgs to the church to see if the monks were 'still at it'. Others joined them. On their arrival at the churchyard gate an awful groan made their hair stand erect with terror. Their fear was increased by the screech of the old white owl as it swooped down upon them from the belfry as

if indignant at their intrusion upon his privacy. Instanter all rushed back to the Owl where those who did not go twitted those who did with funking!

After a few more 'refreshers' it was determined that another attempt should be made. Mr Boffin the active and intelligent parish constable declared that the custody of the Owl and the safeguarding of Mrs Duggle alone prevented him from being one of the party. Gout prevented the Squire from going. As for Mr Pipkin it was found impossible to wake him up!

This time all was still when they came to the churchyard gate except the hissing of the disturbed owls in the belfry. On passing the church porch they beheld that which petrified them with horror. Under the central window of the south aisle they saw four white forms whirling about in a fantastic manner. When they paused, a dread form also robed in white emerged apparently from an open grave. As it vanished the groan was repeated when the four monks resumed their unholy exercise.

At last, with courage begotten of despair old Corporal Jowler who lost his leg in the wars stepped forward and found Farmer Bluggs' old white mare on her back between two graves; the monks were her four white legs!, the form rising from the grave was her body, the groan, her very own as she tried to extricate herself from her uncomfortable position.

Quickly liberating her, they led her to the stable of the Owl where a good supper and a warm bed calmed her agitation. Her rescuers then made their way to the Kitchen where a judicious supply of ardent spirits calmed theirs. The solving of the mystery of the monks on the south side of the church did not upset their belief in their northern haunt. At last the company went to their homes and Betsy went to bed.

The owls still inhabit the belfry. The good old Squire has long been laid to rest in the family vault. The grass waves over the grave of Betsy Duggle and those of many of her patrons. The old inn remains but its sign is changed as are its fortunes which are not for the better but – to this day – on a Christmas Eve very very old men will meet in the Kitchen and tell the tale of old Dorgs and *The Monks' Dance.*

CHAPTER NINE

THE SNETTISHAM GHOST

The Snettisham ghost story is probably the most convincing of the stories of paranormal Norfolk: there seems no other explanation of events, and no reason why anyone should invent it. It was published in a book by the Psychic Press, from which this account is based, but the notes of Anthony Hamond give some extra information which has not appeared in print before.

Mrs Seagrim died at 5 Rodney Place Clifton in Bristol on 22 December 1878: she had only moved in a few days before. Her children stayed in the house for a couple of years and it was later occupied by Mr Ackland. Both groups of people heard strange noises, and Ackland's sister was once in the attic when she felt some water splashed onto her: she thought it was a practical joke by her brother, but he was not in the room.

The story takes off in October 1893, when Mrs Goodeve came to stay in the house: she was a frequent visitor and on one occasion when nursing Mrs Ackland's mother, she had heard footsteps coming and going on the stairs. On 8/9 October she was woken up by a cold wind, even though the windows and the door of her room were shut. Opening her eyes, she saw the face of a woman leaning over her and looking at her intently and very sadly. The face was emaciated but seemed kindly and the head was swathed in a shawl. The woman said, 'Follow me' and went into the drawing room, according to a later account by Mrs Goodeve passing through the locked door. The parlour maid was positive that she had locked the door the previous night and that it was still locked in the morning. The figure went to the far end of the room, turned and spoke to Mrs Goodeve – and then vanished! Mrs Ackland went to bed and next day talked it through with Mr Ackland and with Dr Marshall, a family friend, who had both known Mrs Seagrim and said that the apparition resembled her.

The next night, Mrs Goodeve sat up until about midnight, and then went to bed and fell asleep. She woke up and found the same woman leaning over. The woman said 'I have come, listen!' She then made a statement and asked Mrs Goodeve to do a certain thing. Mrs Goodeve said 'Am I dreaming or is this true?' The spectre answered 'If you doubt me you will find that the date of my marriage was 26 September 1860.'

Snettisham Parish Church

Mrs Goodeve suddenly noticed the apparition was no longer alone. Beside her was a man, tall and dark, and looking about the age of sixty or more. 'He was dressed in a man's ordinary day clothes and had a kind, good expression'. He told her that he was Henry Barnard and that he was buried in Snettisham churchyard, a place of which Mrs Goodeve had never heard. He told Mrs Goodeve the dates of his marriage and burial, and told her to go to Snettisham to see if they were true. If they were, she was to go to the church on the following morning at 1.15 and wait in the south-west corner of the south aisle beside the grave of a man called Richard Cobb who had died 15 May 1743 aged sixty-seven: she was to verify this also from the parish registers. He told her that the outgoing half of her train ticket would not be taken from her and that she was to send this, along with a white rose from his grave, to Dr Marshall. He told her that she was not to go under her own name (she seems to have ignored this wish). When she got to Snettisham she would be helped by a dark man, who must have known Barnard when he was alive, as she was told to describe him to the man when they met. Barnard told her that she would lodge in the house of a woman whose child had been drowned and was buried in the same churchyard. Towards the end of his conversation Mrs Goodeve noticed a third apparition also a man, whose name she was not free to

The Barnard family plot: no headstones remain

give: he was evidently in great trouble and, she recalled, 'his face was so full of misery that I could hardly bear to look upon it'. All three then disappeared and Mrs Goodeve summoned Mr Ackland: the time was 1.20 in the morning.

Mrs Goodeve naturally told her story many times and in some versions it was Mrs Seagrim that insisted on the flower plucking, and Henry Barnard actually bade Mrs Goodeve to go and visit his daughter, saying that she would see the likeness of her father.

The next morning, which was Tuesday, Mrs Goodeve began to try and verify the story. She asked at the local Post Office if there was a place called Snettisham: she was told that indeed there was, in the county of Norfolk. She asked Dr Marshall if they could verify the date of Mrs Seagrim's marriage (which had taken place in India), and he at once wrote to her married daughter.

The reply came on Thursday morning: yes, the date was correct. Mrs Goodeve retuned that evening to London, deciding to go by train to Snettisham on the Saturday. On the night before her journey she had vivid dreams, including that she would miss her train and that she would wile away her time in the British Museum: both came true, as did the dream that when she got to Snettisham it would be dark, all the inns would be full as there was a fair on, and that she would find lodging with a Mr Bishop.

All this came to pass: Bishop turned out to be the parish clerk – and he had a drowned child buried in the churchyard!

Mrs Goodeve went to the morning service in Snettisham church, and then looked at the parish registers: she was able to verify the date of the marriage and burial of Henry Barnard. She went with Bishop and saw the grave of Robert Cobb in the south-west corner of the south aisle. She had previously described her vision to him, and he recognised her ghostly visitor as Henry Barnard, the last owner of Cobb Hall (this is not far from the church, and was later known as Park House). She then went to the curate and asked him to let her visit the church at 1 am the next morning, but not unnaturally he refused: eventually she was able to persuade him, however. In the afternoon she went for a walk, and looked at Cobb Hall from the road: it was now occupied by Barnard's daughter.

At one in the morning, she went over to the church with John Bishop, and he locked her in at about 1.20. He came back for her twenty-five minutes later and took her back to his house where she went to bed and slept soundly: she would never divulge what message she had been given, saying only that she was to pick another rose from Barnard's grave and give it to his daughter: her task would then be done.

'But', says Maitland, 'here enters another factor into this amazing story, to throw light on which I am largely indebted to information, memoirs etc which have been kindly supplied to me by Commander Neville Rolfe and other members of his family. The grave of Henry Barnard, is enclosed in a low, iron fence around which there are still growing some of those white roses mentioned in the story. Other graves, one of them presumably that of Miss Barnard's, are within the same enclosure, and nearby, just across the path, there is yet another enclosure, rather a series of graves, three

Above and below: The Neville-Rolfe plot has also suffered from neglect, but the inscription still survives

in a row. The first of these is that of a Mrs Neville Rolfe and bears the following inscription: 'To teach self-sacrifice and simple faith this stone recalls the sweet memory of Fanny Kunnigunda (Olive) the dearly beloved wife of Charles Neville Rolfe, born 2nd May 1851, died 17th January 1891. And flights of angels sing thee to thy rest'. The next one is that of Mary Ann, wife of Frederick Walpole Keppel, of Lexham Hall, Norfolk, and the third is that of a Mrs Ingleby, who was a Miss Neville Rolfe. When in the church Mrs Goodeve had been told, as far as we can judge from her subsequent remarks, to note the inscription upon Mrs Neville Rolfe's grave and to apply the first part of it to herself. But the name Neville Rolfe had been given to her before that, for in telling her story to Mrs Torrey, a sister of the Mrs Ingleby mentioned above, she said that the names Ingleby and Neville Rolfe had been given to her at Clifton by the figure of Henry Barnard in connection with the quest she had been asked to undertake. At the time she was evidently ignorant of a good deal which she subsequently learnt, for on arriving at Snettisham she enquired from Mrs Bishop what the names of Ingleby and Neville Rolfe had to do with each other, and only then learnt that they were sisters-in-law.

Another curious incident might be mentioned here. When Mrs Torrey, as a member of the Neville Rolfe family, called upon Mrs Goodeve with another member of her family at her house in London, the latter told her that after her adventures in Snettisham, feeling a little overwrought she determined to go quite away, and to a place where nothing would remind her of what she had recently gone through. She went, therefore, to Eastbourne and one day walked into the Wish Tower. Noticing a sketch on the wall, she asked the attendant who painted it. He replied, 'Mrs Ingleby'. Struck by the name, she asked where the lady lived and was told that Mrs Ingleby belonged to Norfolk and lived at Heacham. Mrs Goodeve remarked to Mrs Torrey that she felt at the moment as if the story was pursuing her.'

Subsequent research revealed some possible links between the parties. Henry Barnard had acquired Cobb Hall in about 1860, and there were doubts about this being a legal transaction. Mrs Seagrim's maiden name was Cobb, hence the reference to the Cobb grave – presumably there was a presumed wrong done to the Cobb family. The Cobbs were connected to the Neville Rolfes: Robert Cobb's wife had been a Catherine Rolfe of King's Lynn, and the Rolfe family subsequently named the Neville Rolfes. It was said in Snettisham that if Barnard had not purchased Cobb Hall it would have gone into the Neville Rolfe family.

Mrs Goodeve did not want her story publicised: this was done – to her annoyance – by Marshall. The train ticket had indeed been sent to him. Cynics said that she had bought two tickets so that she would be able to send him one. This was investigated: the railway company were sure that only one ticket was used on that particular train from London to Snettisham and they were totally unable to account for it not having been given up.

Rose Newman's letter

The neighbours in Clifton soon heard the story, presumably through Marshall. Miss Rose Newman of the house next door, 3 Rodney Place, wrote in great excitement to

a friend in Norfolk, Mrs Mary Black in early February 1894: 'I have a thrilling story to tell you. You may have heard perhaps some of it because it has got about so much, greatly to the annoyance of our friend to whom the communication was made. The long and the short of it all is that 5 Rodney Place is haunted, but it has not been much talked of for the last three years. Andrew Lang is wild to get the story for his Psychic Society'. Now this Mrs Black lived near Snettisham – and was a relative of the Neville Rolfes! She went to Snettisham to look into the matter with her son Bertie and daughter (or daughter-in-law) Helen, talking to the vicar's daughter, a Miss Bridgewater, and at once wrote down her account, on the evening of 14 February 1894. According to this statement, 'In October 1893, Mrs Goodeve, a small fragile-looking woman, arrived at Snettisham. She asked the porter to direct her to lodgings, and he took her to one or two places without success. Finally he took her to the house of the parish clerk, a man named Bishop. As soon as Mrs Goodeve learned the name she said that he was the man to whom she had been directed to go.

She first applied to the rector, then to the curate for permission to examine the registers and to enter the church alone at 1.20 at night. The permission to examine the registers by daylight was given to her, but the other request was refused. However the clerk Bishop with whom she lodged had a key, and at 1.20 that night he accompanied her to the church and walked all round it inside with her, carrying a light to make sure that no one was hiding there. Then she told him to put out the light and to go away, locking her into the church. After about half an hour he let her out and she told him that after being about ten minutes inside the church she had seen the man whom she was sent to see. She described him minutely even to his clothes. He was old Mr Barnard who bought the Cobb property after it had been many years in Chancery. She said that he had told her to read the inscription on Mrs Neville Rolfe's tombstone which is just at the foot of his own in the churchyard. This inscription begins: 'To teach self-sacrifice and simple faith', and Bishop insists that it was this part of the inscription that she was to look at. She was told to gather some white roses from his, old Barnard's, grave and to take them to his daughter who now lives alone at Cobb Hall in Snettisham.

Mrs Goodeve went there next morning and had a long interview with Miss Barnard after which she told Bishop that her task was done. She went away that day having paid Bishop handsomely. She afterwards sent him a very nice inkstand. Mrs Bishop, to whom Mrs Goodeve appears to have spoken more freely than to her husband, has kept her information to herself, but says that when Mrs Goodeve arrived she said that the name Ingleby had also been given to her but that she could not see its connection with the other names. Mrs Bishop explained the connection between the Neville Rolfes and the Inglebys but apparently Mrs Goodeve must have told Mrs Bishop something further for, when Helen asked her what the Inglebys had to do with the object of Mrs Goodeve's visit, Mrs Bishop replied that, if she told that it would be telling the whole matter. Helen and Bertie were favourably impressed by the Bishops, who seemed to be superior working-class people. Her father was clerk before him.

One curious point is that Mrs Goodeve had been told by the apparition at Clifton that she would not be asked to give up her ticket at Snettisham station. This actually

happened although the collector there is very particular in collecting tickets. Mrs Goodeve sent the ticket to Dr Marshall as a proof of the spirit's accuracy.' The three of them signed this statement and added a few details: Mrs Goodeve had asked at the station for a man called Bishop, but, as she was wearing fine clothes and travelling first class, they did not connect her with their very humble parish clerk, whose cottage 'is a tiny place, not at all the place one would choose to live in'. They had tried to interview Miss Barnard but had failed: '[she] is a middle-aged person of whom people seem rather afraid'.

John Bishop's statement

Bishop himself wrote an account of the events on 22 October: 'I am clerk of the parish of Snettisham. On Sunday evening, 14th October, a lady who gave the name of Goodeve, after going to several places for lodging, came to my house accompanied by porter and luggage. I accommodated the lady with lodgings. She told me that she wanted to look at the church registers, and did I think the curate would come and speak to her at my house. I told her that I thought he would, as she would like to see them on Sunday. The lady then sent note by porter to curate who was just going out to dinner so did not come till half-past eleven, when lady had retired to bed. He asked me to apologise to her for not coming to her before, but would be happy for her to see registers on Sunday morning after service.

The lady came to morning service and afterwards came to vestry and asked for registers of Robert Cobb and Henry Barnard, also giving description of Henry Barnard, which was quite correct, and dates of registers also correspond with those in the lady's journal. I then showed her the tombstone of Robert Cobb, and also the grave of Henry Barnard. Curate refused to assist lady any further, the lady then asked me whether I would accompany her to the church at twenty minutes past one Monday morning. I told her that I could not give a decided answer just then but would do so after evening service. Spoke to the curate on the matter after service. He told me that I should not have anything more to do with it, but that I could do as I liked. I then told the lady that I would do as requested. At a quarter to one I called her. We then proceeded to the church at twenty past one o'clock, and after looking all round the interior I left the lady in the church at twenty past one o'clock in total darkness, locking the door on the outside. At twenty minutes to two o'clock by the lady's request I gave three slight taps on the door, unlocked it, when the lady came out. We then went to grave of Henry Barnard where the lady plucked some roses. We then returned home reaching home about two o'clock. Signed John Bishop, Parish Clerk.

Some sixty years later, Maitland wrote to the only one in Snettisham likely to remember the events, Bishop's son. The reply was 'I am afraid I cannot help you as whatever the secret was, my mother was the only person in whom Mrs Goodeve confided. She died twenty years ago without ever having divulged anything, not even to my father. The only part he was concerned in was to admit Mrs Goodeve into the church at 1 am. As regards staying with Mrs Goodeve I did that pretty often in my younger days. The address was 2 Collingham Road, Cromwell Road, Kensington.'

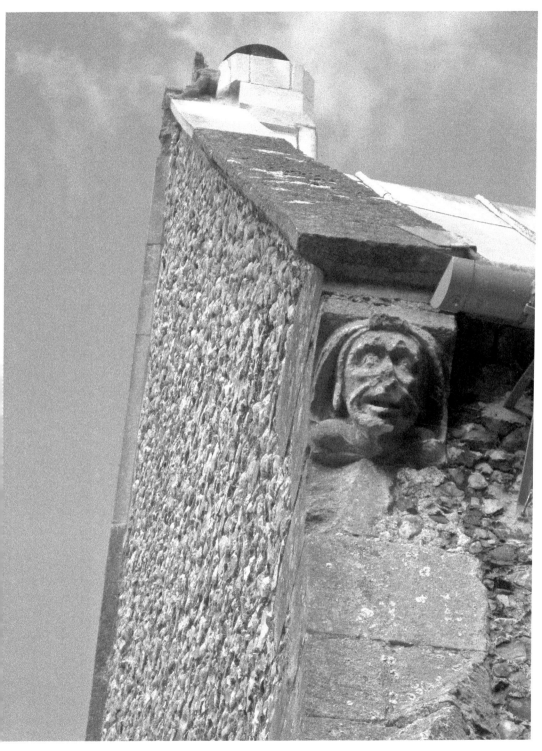

This stone figure on Snettisham church looks towards the Barnard graves: he could tell many secrets

Revd Rowland W. Maitland wrote a book published by the Psychic Press Ltd about sixty years ago, using evidence gathered by Frederick Myers and used in a paper he wrote called *The Subliminal Self* and published by the Society for Psychical Research. I have given the story as recorded by Maitland.

Anthony Hamond's contribution

Inevitably, other people know slightly differing versions of the story. Anthony Hamond heard it twenty or thirty years later, the story being known to his grandmother. His notes explain the background to the events. A Mr Digby wrote in 1894: 'A family of Cobbs owned Snettisham Park Farm from the time of Queen Elizabeth to the beginning of this century [that is, about 1800], then somehow the place was for sale and I believe has been sold twice for a very little as no title deeds were forthcoming. The last time it was for sale a man I knew very well wanted to buy it as his property adjoins but it fell through as there were no title deeds produced but a retired farmer named Barnard bought it for less than its value but did not move into it for more than a year in case his title was not good. He is dead and an old Miss Barnard lives there'. There was still an element of secrecy: the lady who told Digby the story 'hardly spoke out of a whisper for fear others should hear.'

By the time, Hamond set down the story as he knew it, even the name of the woman had been forgotten: 'who she was no one now remembers if indeed they ever knew'. In his version she was living near Bristol with her sister who was very ill. One night there was a knock at the door and a middle aged lady and gentleman came in, very well dressed and obviously an old country squire and his wife. They told her that she alone was able to right a great wrong. When she objected that she could not leave her sister, they said, 'Oh – she will die in a few days time and we will come back when you have thought it over'. She died a few days later, and the visitors returned after the funeral to give their orders. They told her she must catch such and such a train, go across London and catch such and such a train at 'I think' Liverpool Street. At Snettisham she would be helped by a man with a black beard. The instruction she was given was to go into the church at night and to 'pluck a rose from the North Wall of the church'. The following day she must go up a certain road at the back of the village to a certain house and knock at the door. A woman would answer the door, she must then hand in the rose and the answer would be 'That will be quite alright, thank you'. She must then ask to see the lady of the house and gain permission to look in a certain drawer in a certain piece of furniture in a certain room and to bring away the contents.

She caught her train, crossed London and at Liverpool Street the porter said, 'You are an hour or so early for your train but if you run you will catch the one before it'. She ran and caught the train but had to get off again as the porter failed to turn up in time with her suitcase owing to being 'detained by a lady and gentleman': she was obviously meant to follow the instructions to the letter. In this version the man with a black beard who gave her lodging was a different man than the person who let her into the church, here called the sexton. The sexton stayed outside the church but according to Hamond he too saw the ghostly visitors, he was shaking all over and almost speechless when she came out, and could only say, 'Do you know who that was

what come out in front of you? That was old Squire —— and his wife what ha' been dead these twenty year or more'.

She went next day to the house. The woman there took the proffered rose and answered just as had been predicted. However, when the visitor asked to look in the drawer, she would not allow it. She went back to London and spent the night there. She was again visited that night and told 'We have come to thank you for all you have done to help us. We realise we have failed but it is through no fault of yours. There are three deaths in the way'. With that cryptic remark, they disappeared for ever.

Hamond had his own ideas about the rose. 'The most important thing is that some say the words were 'break off a rose' as opposed to 'pluck a rose'. If it were 'break off' it would obviously imply a carved stone or wooden flower which I feel is more likely. There has apparently always been something uncanny associated with the porch of Snettisham Church especially I am told around Christmas time and the middle of December. This may or may not have any bearing on the subject but is worthy of note I think.

I forgot to mention that it was from a tombstone that she was to break off the rose. This has led some people to think that it might have been a rose growing outside the church but I have been to see for myself. Up in the north east corner of the church on the north wall there is a large Elizabethan tomb railed in behind a projecting barrier of spiked railings. On the ceiling of this tomb, under the arcade there is a carved rose bud, the last survivor of many others which formerly studded the underneath of the arch. It would be impossible for a woman holding a candle to reach any of them. Further investigation shows that the builders of the tomb left one of the railings loose so that it can be lifted and a small person could squeeze behind. Now on the lower part of the tomb within fairly easy reach of someone outside the railings there are two marks, one on either side and on closer inspection it will be found that there were formerly two Tudor roses attached here as part of the decoration. In one case the outline of the five petals was to me quite clear. Surely it was here that she 'broke off a rose from a tomb on the north side of the church'.

Hamond added a curious detail, that some local people thought that the strange woman in Snettisham might be 'one of the suffragettes what they have in some parts'. This is probably a memory of a later occasion, the by-election in the area in 1912, when suffragettes did come to the towns and villages of north-west Norfolk to try to persuade voters to support the cause: this story will be told in my book on the suffragette movement.

The author's contribution

Mrs Goodeve was asked to check three entries in the Snettisham parish registers: Cobb's burial and Barnard's marriage and burial. It is significant that we are told only that she confirmed the last two: the Snettisham registers are now in the Norfolk Record Office, but there is a gap between 1733 and 1759. The register for this period has disappeared and if it had already been lost, then Mrs Goodeve would not have been able to check the Cobb burial. However she *would* have been able to confirm the other two entries: Henry Barnard was buried at Snettisham on 7 August 1878,

aged seventy-two. He had married in the parish church on 7 November 1837, his bride being a lady named Anne Headley. I also made two other small discoveries in the registers: Barnard could not have seen Olive Neville-Rolfe's tomb, with its words of inspiration, in his own lifetime: she was buried on 21 January 1891. As it would take some months to organise the headstone it must have been pretty new when Mrs Goodeve saw it in 1893. One other small detail, the mentions of a child of the people with whom she stayed being drowned turn out to be true: Percival Bishop died by accidental drowning in July 1886: he was only six years old.

THE GHOST AT SYDERSTONE PARSONAGE

Perhaps the ghost in Norfolk with the most respectable witnesses is that of Syderstone, heard and occasionally seen over a period of forty years, and on one occasion by no less than seven adults – five of them Church of England clergymen! The story is told here directly as it unfolded in the correspondence columns of the *Norfolk Chronicle* over the spring and summer of 1833. I have new information, however, which has not appeared before in print. A century after the story was at its peak, the antiquarian Norman Fourdrinier was living at the parsonage and he had access to a letter by John Stewart to his sister in Ireland, which he has transcribed. I have also my own ideas as to the identity of the ghost!

John Stewart came to Syderstone parsonage in 1832, with his wife and four children. He was a forceful character, and Irishman who had served in the British Army in Spain, but also a writer of poetry and theology. He immediately set about 'improving' the church, with a new pulpit, new pews and lighting. However, he is better known for his role in the ghostly events in his home, set out in the newspaper:

1 June 1833: The following circumstance has been creating some agitation in the neighbourhood of Syderstone for the last few weeks. In Syderstone Parsonage lives the Revd Mr Stewart, curate, and rector of Thwaite. About six weeks since an unaccountable knocking was heard in the middle of the night. The family became alarmed, not being able to discover the cause. Since then it has gradually been becoming more violent, until it has now arrived at such a frightful pitch that one of the servants has left through absolute terror. The noises commence almost every morning about two, and continue until daylight. Sometimes it is a knocking, now in the ceiling overhead, now in the wall, and now directly under the feet; sometimes it is a low moaning which the reverend gentleman says reminds him very much of the moans of a soldier on being whipped; and sometimes it is like the sounding of brass, the rattling of iron, or the clashing of earthenware or glass, but nothing in the house is disturbed. It never speaks, but will beat to a lively tune, and moan at a solemn one, especially at the morning and evening hymns. Every part of the house has been carefully examined, to see that no one could be secreted, and the doors and windows

are always fastened with the greatest caution. Both the inside and the outside of the house have been carefully examined during the time of the noises, which always arouse the family from their slumbers, and oblige them to get up, but nothing has been discovered. It is heard by everyone present, and several ladies and gentlemen in the neighbourhood, who, to satisfy themselves, have remained all night with Mr Stewart's family, have heard the same noise, and have been equally surprised and frightened. Mr Stewart has also offered any of the trades people in the village an opportunity of remaining in the house and convincing themselves. The shrieking last Wednesday week was terrific. It was formerly repeated in the village that the house was haunted by a Rev gentleman whose name was Mantle, who died there about 27 years since, and this is now generally believed to be the case. His vault, in the inside of the church, has lately been repaired, and a new stone put down. The house is adjoining the churchyard, which has added in no inconsiderable degree to the horror which pervades the villagers. The delusion must be very ingeniously conducted, but at this time of day scarcely anyone can be found to believe these noises proceeded from any other than natural causes.

On Wednesday se'night, Mr Stewart requested several most respectable gentlemen to sit up all night, namely the Rev Mr Spurgeon of Docking, the Rev Mr Goggs of Creake, the Rev Mr Lloyd of Massingham, the Rev Mr Titlow of Norwich, and Mr Banks, surgeon of Holt, and also Mrs Spurgeon. Especial care was taken that no tricks should be played by the servants; but, as if to give the visitors a grand treat, the noises were even louder and of longer continuance than usual. The first commencement was in the bed-chamber of Miss Stewart, and seemed like the clawing of a voracious animal after its prey. Mrs Spurgeon was at the moment leaning against the bed-post, and the effect on all present was like a shock of electricity. The bed was on all sides clear from the wall; – but nothing was visible. Three powerful knocks were then given to the sideboard, whilst the hand of Mr Goggs was upon it. The disturber was conjured to speak, but answered only by a low hollow moaning; but on being requested to give three knocks it gave three most tremendous blows apparently in the wall. The noises, some of which were as loud as those of a hammer on the anvil, lasted from between 11 and 12 o'clock until near two hours after sunrise. The following is the account given by one of the gentleman – 'We all heard distinct sounds of various kinds – from various parts of the room and the air – in the midst of us – nay we felt the vibrations of parts of the bed as struck; but we were quite unable to assign any possible natural cause as producing all or any part of this. We had a variety of thoughts and explanations passing in our minds *before* we were on the spot, but we all left it equally bewildered.' On another night the family collected in a room where the noise had never been heard; the maid-servants sat sewing round a table, under the especial notice of Mrs Stewart, and the man-servant, with his legs crossed and his hands upon his knees, under the cognizance of his master. The noise was then for the first time heard there – 'above, around, beneath, confusion all' – but nothing seen, nothing disturbed, nothing felt, except a vibratory agitation of the air, or a tremulous movement of the tables or what was upon them. It would be in vain to attempt to particularise all the various noises, knockings and melancholy groanings

Syderstone village street, almost unchanged since the time of the hauntings

of this mysterious something. Few nights pass away without its visitation, and each one brings its own variety. We have little doubt that we shall eventually learn that this midnight disturber is but another 'Tommy Tadpole', but from the respectability and superior intelligence of the parties who have attempted to investigate into the secret, we are quite willing to allow to the believers in the earthly visitations of ghosts all the support which this circumstance will allow to their creed – that of *unaccountable mystery*. We understand that enquiries on the subject have been very numerous, and we believe we may say troublesome, if not expensive.

8 June, letters from John Spurgin and Samuel Titlow

Spurgin: My name having appeared in the Bury Post as well as in your own Journal without my consent or knowledge, I doubt not you will allow me the opportunity of occupying some portion of your paper, in way of explanation.

It is most true that, at the request of the Rev Mr Stewart, I was at the Parsonage at Syderstone on the night of the 15th ult, for the purpose of investigating the cause of the several interruptions to which Mr Stewart and his family have been subject for the past three or four months. I feel it right therefore to correct some of the erroneous impressions, which the paragraph in question is calculated to make upon the public

mind; and at the same time to state fairly the leading circumstances which transpired that night.

At ten minutes before two in the morning, *knocks* were distinctly heard; they continued at intervals until after sun-rise – sometimes proceeding from the bed's head, sometimes from the side-boards of the children's bed, sometimes from a three-inch partition, separating the children's sleeping rooms; both sides of which partition were open to observation. On two or three occasions, also, when a definite number of blows was required to be given, the precise number required was distinctly heard. *How* these blows were occasioned was the subject of diligent search: every object was before us, but nothing satisfactorily to account for them: no trace of any human hand, or of mechanical power, was to be discovered. Still, I would remark, though perfectly distinct, these knocks were by no means so powerful as your paragraph represents – indeed, instead of '*being even louder, and of longer continuance that night, as if to give the visitors a grand treat*' – it would seem they were neither *so* loud nor *so* frequent as they had commonly been. In several instances they were particularly gentle, and the pauses between them afforded all who were present, the opportunity of exercising the most calm judgement and deliberate investigation.

I would next notice the '*vibrations*' on the side-board and posts of the children's beds. These were distinctly felt by myself as well as others, not only once, but frequently. They were obviously the result of different blows, given in some way or other, upon the different parts of the beds, in several instances when these parts were actually under our hands. It is not true that '*the effect on all present was like a shock of electricity*' – but that those '*vibrations*' did take place, and that too in beds, perfectly disjointed from every wall, was obvious to our senses; though in what way they were occasioned could not be developed.

Again – our attention was directed at different times during the night, to certain sounds on the bed's-head and walls, resembling the scratching of two or three fingers; but *in no* instance were they like '*the clawing of a voracious animal after its prey*'. During the night I happened to leave the spot in which the party were assembled, and to wander in the dark to some more distant rooms in the house, occupied by no member of the family, (but where the disturbances originally arose), and there, to my astonishment, the same scratchings were to be heard.

At another time also, when one of Mr Stewart's children was requested to hum a lively air, '*most scientific beatings*' to every note was distinctly from the bed-head; and, at its close, *four blows* were given, louder (I think) and more rapid than any which had before occurred.

Neither ought I to omit that, at the commencement of the noises, several feeble 'moans' were heard. This happened more than once; after a time they increased to a series of '*groanings*' of a peculiarly distressing character, and proceeding (as it seemed) from the bed of one of Mr Stewart's children, about ten years of age. From the tone of voice, as well as other circumstances, my own conviction is, that these 'moans' could not rise from any effort on the part of the child. Perhaps there were others present who might have had different impressions; but be this as it may, towards day-break four or six shrieks were heard – not from any bed or wall, but as hovering in the atmosphere

of the room, where the other noises had been principally heard. These screams were distinctly heard by *all,* but their cause was discoverable by *none.*

These, sir, are the chief events which occurred at Syderstone Parsonage on the night alluded to in your paragraph. I understand the *'knockings'* and 'sounds' have varied considerably in their character on different nights; and that there have been several nights occurring (at four distinct periods) in which *no noises* have been heard.

I have simply related what took place under my own observation. You will perceive that the noises heard by us, were by no means so loud and violent as would be gathered from the representations which have been made. Still, as you are aware, they are not on that account the less real; nor do they, on that account, require the less rational explanation. I trust, however, Mr Editor, your readers will fully understand me. I have not related the occurrences of the night for the purposes of leading them to any particular views, or conclusions upon a subject which, for the present at least, is wrapt in obscurity; such is very remote from my object. But Mr Stewart having requested me, as a neighbouring Clergyman, to witness the inconveniences and interruptions to which the different members of his family have been subject for the last sixteen weeks – I have felt it my duty, as an honest man, (particularly among the false statements now abroad) to bear my feeble testimony, however inconsiderable it may be, to their actual existence in his house; and also since, from the very nature of the case – it is not possible Mr Stewart can admit the repeated introduction of strangers to his family. I have thought it, likewise, a duty I owed to the public to place before them the circumstances which really did take place on that occasion. In the words of your paragraph, I can truly say – '*I had a variety of thoughts and explanations passing in my mind before I was on the spot, but I left it perfectly bewildered!*' – and I must confess the perplexity has not been diminished by the result of an investigation, which was most carefully pursued for five days during the past week, under the immediate direction of Mr Reeve, of Houghton, agent to the Marquis of Cholmondeley, the Proprietor of Syderstone and patron of the Rectory – and who, on learning the annoyances to which Mr Stewart was subject, directed every practicable aid to be afforded for the purpose of discovery; Mr Seppings and Mr Savory, the two chief inhabitants of the parish, assisted also in the investigation. A 'trench' was dug round the back parts of the house, and borings were resorted to in all other parts of it to the depth of six or seven feet, completing a chain round the entire buildings, for the purpose of discovering any subterranean communication with the walls, which might possibly explain the noises in question. Many parts of the interior of the house also, such walls, floors, false roofs etc have been minutely examined, but nothing has been found to throw any light upon the source of the disturbance. Indeed, I understand the *knockings* within the last four days, so far from having subsided, are become increasingly distressing to Mr Stewart to his family – and so *remain*!

John Spurgin, Docking, 5 June 1833

Sir, the detail of circumstances connected with the *Syderstone Ghost,* as reported in the public papers, is in my opinion very incorrect, and calculated to deceive the public. If the report of noises heard on other evenings be as much exaggerated, as is the report of

The Parsonage hides behind this high brick wall

noises which five other gentlemen and myself heard on Wednesday evening, the 15th of May, nothing could be better contrived to foster superstition and to aid deception. I was spending a few days with a friend in the neighbourhood of Syderstone, and was courteously invited by Mr Stewart to sit up at the Parsonage, but I never imagined the noises I heard during the night would become a subject of general conversation in our city and county; as such is the case, and as I have so frequently appealed to by personal friends, I hope you will afford the convenience of correcting, through the medium of your journal, some of the errors committed in the reports made of the disturbances which occurred when I was present. If the other visitors thought proper to make their statements known to the public, I have no doubt they would nearly accord with my own, as we are not, though so represented in the *Bury Post*, 'those who deal in contradictions of this sort'.

The noises were not loud; certainly they were not so loud as to be heard by those ladies and gentlemen who were sitting at the time of their commencement in a bedroom only a few yards distant. The noises commenced as nearly as possible at the hour we had been prepared to expect they would; or at about half-past one o'clock a m. It is true that knocks seemed to be given, or actually were given, on the

The Parsonage as rebuilt after Stewart left Syderstone

sideboard of a bed while Mr Goggs' hands were upon it; but it is not true that they were 'powerful knocks'. It is also true that Mr Goggs requested the ghost, if he could not speak, to give three knocks, and that three knocks, gentle knocks not 'three most tremendous blows', were heard, as proceeding from the thin wall, against which were the beds of the children and the female servants. I heard a scream as of a female, but I was not alarmed; I cannot speak *positively* as to the origin of the scream, but I cannot deny that such a scream may be produced by a ventriloquist. The family are highly respectable, and I do not know any good reason for a suspicion to be excited against any one of the members; but as it is possible for one or two members of a family to cause disturbances to the rest, I must confess that I should be more satisfied that there is not a connexion between the ghost and a member of the family, if the noises were distinctly heard in the rooms when all the members of the family were known to be at a distance from them. I understood from Mr Stewart that on one occasion the whole family, himself, Mrs Stewart, the children, and servants, sat up in his bed-room during the night, that himself and Mrs Stewart kept an attentive watch upon the children and servants, and that the noises, though seldom or never heard before in that room, were then heard in all parts of the room. This fact, though not

yet accounted for, is not a proof but that someone or more of the family is able to give full information on the cause of the noises.

Mr Stewart and other gentlemen declared that they have heard such a loud violent knocking, and other strange noises, as certainly throw a great mystery over the circumstance; I speak only in reference to the knockings and the scream which I heard when in company with the gentlemen whose names have already been made known to the public, and confining my remarks to those noises, I hesitate not to declare that I think similar noises might be caused by visible and internal agency.

I do not deny the existence of supernatural agency, or its occasional manifestation; but I firmly believe such a manifestation does not take place without divine permission, and when permitted it is not for trifling purposes, nor accompanied with *trifling effects*. Now there are effects which appear to me *trifling*, connected with the noises at Syderstone, and which therefore tend to satisfy my mind that they are *not caused by supernatural agency*. On one occasion the ghost was desired to give ten knocks; he gave nine, and as if recollecting himself that the number was not completed, he began again, and gave ten. I heard him beat time to a lively air of the verse of a song sung by Miss Stewart, if I mistake not, 'Home Sweet Home': and I heard him give three knocks in compliance with Mr Goggs' request.

Mr Editor, noises are heard in Syderstone Parsonage, the cause or agency of which is at present unknown to the public, but a full, diligent investigation ought *immediately* to be made – Mr Stewart, I believe, is willing to afford facility. If therefore I may express an opinion, that two or three active and experienced police officers from Norwich were permitted to be the sole occupants in the house for a few nights, the ghost would not interrupt their slumbers, or if he attempted to do it, they would quickly find him out, and teach him better manners for the future. The disturbances at the Parsonage House in Epworth in 1716 in some particulars resemble those which have occurred at Syderstone, but in these days we give little credence to tales of witchcraft, or that evil spirits are permitted to indicate their displeasure at prayers being offered for the King etc, and therefore I hope that deceptions practised at Syderstone, if they be deceptions, will be promptly discovered, lest that parsonage become equal in repute to the one at Epworth.

Samuel Titlow Norwich 5 June 1833

15 June. Having already borne my testimony to the occurrences of the night of the 15th ult in the Parsonage at Syderstone, and finding that *Ventriloquism and other Devices* are now resorted to as the probable causes of them (and that too under the sanction of certain statements put forth in your last week's paper), I feel myself called on to state publicly that, although a diligent observer of the different events that then took place, I witnessed no one circumstance which could induce me to indulge a conjecture that the *knocks, vibrations, scratchings, groanings* etc which I heard, proceeded from any member of Mr Stewart's family, through the medium of mechanical trickery: indeed it would seem to me utterly impossible that the scratchings which fell under my observation during the night, in a remote room of the house, could be so produced, as, at that time, every member of Mr Stewart's family was removed a considerable distance from the spot.

Grave of Phoebe Steward, one of the witnesses of the Syderstone Parsonage haunting

While making this declaration, I beg to state, that my only object, in bearing any part in this mysterious affair, has been to investigate and to elicit the *truth*. I have ever desired to approach it without *pre-judging* it – that is, with a mind willing to be influenced by *facts* alone – without any inclination to establish either the intervention of *human* agency on the one hand, or of *super-human* agency on the other hand: at the same time, it is but common honesty to state, that Mr Stewart expresses himself so fully conscious of his own integrity towards the public, that he has resolved on suffering all the imputations and reflections which *have* been or which may be cast either upon himself or upon his family, to pass without remark; and as he has, at different times and on different occasions, so fully satisfied his own mind on the *impossibility* of the disturbances in question arising from the agency of any member of his household (and from the incessant research he has made on this point he himself must be the best judge). Mr Stewart intends declining all future interruptions of his family by the interference of strangers.

Perhaps, Mr Editor, your distant readers may not be aware that Mr Stewart has not been resident at Syderstone more than 14 months, while mysterious noises are now proved to have been heard in this house, at different intervals and in different degrees of violence, for the last 30 years and upwards. Most conclusive and satisfactory

Affidavits on this point are now in progress, of the completion of which you shall have notice in due time.

<div align="right">

John Spurgin Docking 7 June 1833

</div>

22 June. For the information of the public, as well as for the protection of the family now occupying the above residence, from the most ungenerous aspersions, the subjoined documents have been prepared. These documents, it was proposed, should appear before the public as Affidavits, but a question of law having arisen as to the authority of the magistrates to receive Affidavits on subjects of this nature; the *Declarations* here under furnished have been adopted in their stead. The witnesses whose testimony is afforded have all been *separately* examined – their statements in every instance, have been most cheerfully afforded – and the solemn impression under which the evidence of some of them particularly has been recorded, has served to show how deeply the events in question have been fixed in their recollection. Without entering upon the question of *Causes*, one *Fact*, it is presumed, must be obvious to all, (namely) *'That various inexplicable noises have been heard in the above residence, at different intervals, and in different degrees of violence, for many years before the present occupiers ever entered upon it'*. Indeed the testimony of other respectable persons to this *Fact* might have

Above and opposite: Syderstone church, with Dudley's emblem over the entrance

been easily adduced, but it is not likely that any who are disposed to reject or question the subjoined evidence would be influenced by any additional testimony which could be presented.

ELIZABETH GOFF of Docking in the county of Norfolk, widow, now voluntarily declareth (and is prepared at any time to confirm the same on oath and say): that she entered into the service of the Rev William Mantle, about the month of April 1785, at which time her said master removed from Docking to the Parsonage at Syderstone, and the said Elizabeth Goff further states that at the time of entering upon the said Parsonage two of the sleeping-rooms therein were nailed up: and upon one occasion, during the six months of her continuance in the service of her said master, she well remembers the whole family were very much alarmed in consequence of Mrs Mantle's sister having either seen or heard something very unusual, in one of the sleeping-rooms over the kitchen, which had greatly terrified her. This declaration was made and signed this 18th day of June 1833, before me, Derick Hoste, one of His Majesty's Justices of the Peace for the county of Norfolk.

The mark X of Elizabeth Goff

ELIZABETH, the wife of GEORGE PARSONS of Syderstone in the county of Norfolk, blacksmith, now voluntarily declareth (and is prepared at any time to confirm the same on oath and say): that she married about 10 years ago, and then entered upon the occupation of the south-end of the parsonage at Syderstone, in which house she continued to reside for the space of nine years and a half. That she, the said Elizabeth Parsons, having lived at Fakenham previously to her marriage, was ignorant of the reputed circumstances of noises being heard in the said house, and continued so for about nine or ten months after entering upon it; but that, at the end of that time, upon one occasion during the night she remembers to have been awoken by some very violent and very rapid knocks in the lower room occupied by them, immediately under the chamber in which she was sleeping; that the noise appeared to be as against the stove which she supposed must have been broken to pieces; that she, the said Elizabeth Parsons, awoke her husband, who instantly heard the same noise; that he immediately arose, struck a light, and went down stairs; but that, upon entering the room he found everything perfectly safe as it had been left upon their going to bed; that her husband thereupon returned to the sleeping-room, put out the light and went to bed; but scarcely had he settled himself in bed, before the same heavy blows returned; and were heard by both of them for a considerable time. This being the first of the noises she the said Elizabeth Parsons ever heard, she was greatly alarmed, and requested her husband not to go to sleep while they lasted, lest she should die from fear; but as to the causes of these noises she, the said Elizabeth Parsons, cannot in anywise account. And the said Elizabeth Parsons further states, that, about a year afterwards at midnight, during one of her confinements, her attention was particularly called to some strange noises heard from the lower room. These noises were very violent, and, as much as she remembers, were like the opening and tossing up and down of the sashes, the bursting of the shutters, and the crashing of the chairs placed at the windows: – that her nurse

hereupon went down stairs to examine the state of the room, but, to the surprise of all, found everything perfectly in order, as she had left it. And likewise the said Elizabeth Parsons further states, that besides the occurrences hereinbefore particularly stated (and which remain quite fresh in her recollection) this was, from time to time, during her residence in Syderstone Parsonage, constantly interrupted by very frightful and unusual knockings, various and irregular, sometimes they were heard in one part of the house, and sometimes in another, sometimes they were frequent, and sometimes two or three weeks or months or even 12 months would pass without any knock being heard. That these knocks were usually never given till the family were all at rest at night, and she has frequently remarked, 'just at the time she hoped she had got rid of them, they returned to the house with increased violence'. And finally the said Elizabeth Parsons declares, that during a residence in the Syderstone Parsonage of upwards of nine years, knocks and noises were heard by her therein, for which she was utterly unable to assign any cause. This declaration was made and signed this 18th day of June 1833, before me, Derick Hoste, one of His Majesty's Justices of the Peace for the county of Norfolk.

Elizabeth Parsons

THOMAS MASE of Syderstone carpenter. One night about eleven years ago, while Mr George Parsons occupied part of the parsonage of Syderstone, he happened to be sleeping in the attic there, and about midnight he heard (he thinks he was awoke out of sleep), a dreadful noise, like the sudden and awful fall of a part of the chimney upon the stove in the lower sitting room. That the crash was so great that, although at a considerable distance from the spot, he distinctly heard the noise, not doubting the chimney had fallen and smashed the stove to pieces; that he arose and went downstairs (it being a light summer's night); but upon examining the state of the room and stove, he found to his astonishment everything as it ought to have been. And the said Thomas Mase further states, that, upon another occasion, about eight or nine years ago, while sleeping a night in Syderstone Parsonage, in a room at the south end thereof (the door of which room moved particularly hard upon the floor, requiring to be lifted up in order to close or open it, and producing a particular sound in its movement), he distinctly heard all the sound which accompanied its opening. That he felt certain the door was opened, and arose from his bed to shut it, but, to his great surprise, he found the door closed, just as he had left it. And finally, the said Thomas Mase states that the circumstances above related, arose from causes which he is wholly at a loss to explain.

WILLIAM OFIELD of Syderstone, gardener and groom. That he lived in the service of the Rev Thomas Skrimshire, about nine years ago, at which time his master entered into the occupation of the said Parsonage at Syderstone, and that he continued with him during his residence in that place. The said William Ofield also states that, as he did not sleep in the house, he knows but little of what took place therein during the night, but that he perfectly remembers, on one occasion, while sitting in the kitchen, he heard in the bedroom immediately above his head, a noise resembling the dragging of furniture about the room, accompanied with the fall as of some very heavy substance

upon the floor. That he is certain this noise did take place, and verily believes that no one member of the family was in the room at the time. The said William Ofield likewise states, that the noise was loud enough to alarm part of the family then sitting in the lower room, in the opposite extremity of the house; that he is quite sure they were alarmed, inasmuch as one of the ladies immediately hastened to the kitchen, to make enquiry about the noise, though his late master's family never seemed desirous of making much of these occurrences. That he the said William Ofield was ordered to go upstairs to see what had happened, and upon entering the room he found everything right – he has no hesitation in declaring that this noise was not occasioned by any person in the house. The said William Ofield likewise states, that, at different times during the evenings, while he was in his said master's service, he has heard other strange noises about the house, which he could never account for, particularly the rattling of glass and china in the chiffonier standing in the drawing room, as if a cat were running in the midst of them, while he well believes that no cat could be in there as the door was locked. And the said William Ofield likewise states, that he has been requested by some of the female servants of the family, who had been frightened, to search the false roof of the house, and, to quiet their alarms, he has done so, but could never discover anything out of order.

ELIZABETH the wife of John HOOK labourer of Syderstone. That she entered service of the Rev Thomas Skrimshire at Syderstone Parsonage about seven years ago, and continued with him about four years, that in the last year of her service with Mr Skrimshire, about Christmas time, she heard a noise resembling the moving and rattling of the chairs about the sleeping room immediately over her; that the noise was so great that one of Mr Skrimshire's daughters came out of the drawing room, which was removed a considerable distance from the spot in which the noise was heard, to make enquiry about it; that the man servant and part of the family went upstairs, but found nothing displaced; and moreover that she verily believes no member of the family was upstairs at the time. The said Elizabeth Hook also states, that, upon another occasion, after the above event, as she was going up the attic stairs to bed, with her fellow servant, about 11 o'clock at night, she heard three loud and very distinct knocks, as coming from the door of the false roof. These knocks were also heard by the ladies of the family, then separating for the night, who tried to persuade her it was someone knocking at the hall door. The said Elizabeth Hook says that, although convinced it was from no person outdoors, yet she opened the casement to look, and, as she expected, found no one, indeed, being closest to the spot on which the blows were struck, she is sure they were on the door, but how and by whom given, she is quite at a loss to conjecture. And finally the said Elizabeth Hook states, that, at another time, after she had got into her sleeping room, (the whole family besides being in bed and she herself sitting up working at her needle) she heard noises in the passage leading to the room, like a person walking with a peculiar hop; that she was alarmed, and verily believes it was not occasioned by any member of the family.

PHOEBE STEWARD of Syderstone, widow. That about 20 years ago, a few days after Michaelmas, she was left in charge of Syderstone Parsonage then occupied by Mr Henry Crafer; and about eight o'clock in the evening, while sitting in the kitchen, after securing all the doors, and no other person being in the house, she heard great noises in the sleeping rooms over her head, as of persons 'running out of one room into another' – 'stumping about very loud' – and that these noises continued about ten minutes or a quarter of an hour, that she felt the more alarmed, being satisfied there was, at that time, no one but herself in the house. And the said Phoebe Steward further states, that on Whitsun Tuesday 18 years ago, she was called to attend, as nurse, on Mrs Elizabeth Parsons, in one of her apartments, then living in Syderstone Parsonage. That about a fortnight after that time, one night, about 12 o'clock, having just got her patient to bed, she remembers to have plainly heard the footsteps, as of someone walking from their sleeping room door, down the stairs, step by step, to the door of the sitting room below; that she distinctly heard the sitting room door open, and the chair placed near one of the windows moved, and the shutters opened. All this the said Phoebe Steward is quite sure she distinctly heard, and thereupon immediately, upon being desired, she came downstairs, in company with another female, whom she had awakened to go with her, being too much alarmed to go by herself; but on entering the room she found everything just as she had left it. And the said Phoebe Steward further states, that about a fortnight after the last-named event, while sleeping on a bureau bedstead in one of the lower rooms in Syderstone Parsonage (that is, in the room referred to in the last statement), she heard ' a very surprising and frightful knock, as if it had struck the head of the bed and dashed it in pieces'; that this knock was so violent as to be heard by Mrs Crafer in the centre of the house; that she, the said Phoebe Steward, and another person who was at that time sleeping with her, were very much alarmed by this heavy blow, and never knew how to account for it. And finally, the said Phoebe Stewart states, that during the 45 years she has been in the habit of frequenting the Syderstone Parsonage (without referring to any extraordinary statements she has heard from her sister, now dead, and others who have resided in it), that she, from her own positive experience, has no hesitation in declaring, that in that residence noises do exist which have never been attempted to be explained.

ROBERT HUNTER of Syderstone, shepherd. That for 25 years he has lived in the capacity of shepherd with Mr Thomas Seppings, and that one night in the early part of March 1832, between the hours of ten and eleven o'clock, as he was passing behind the Parsonage at Syderstone, in a pathway across the glebe land near the house, when within about 12 yards of the back parts of the buildings, his attention was arrested all on a sudden by some very loud 'groanings' like those of 'a dying man, solemn and lamentable', coming (as it seemed to him) from the centre of the house above; That the said Robert Hunter is satisfied that these groans had but then just begun, otherwise he must have heard them long before he approached so near the house. He also further states, that he was much alarmed at these groans, knowing particularly that the Parsonage at that time was wholly unoccupied, it being about a month before Mr Stewart's family came into residence there; that these groans made such an impression

on his mind, as he shall never lose, to his dying hour. And the said Robert Hunter likewise states, that, after stopping for a season near the house, and satisfying himself of the reality of these groans, he passed on his way, and continued to hear them as he walked, for the distance of not less than 100 yards. The said Robert Hunter knows that 100 yards is a great way, yet (if he had stopped and listened), he, the said Robert Hunter, doubts not, he could have heard them to a still greater distance than 100 yards, so loud and so fearful were they that never did he hear the like before.

Thomas Seppings and John Savory, as 'chief inhabitants of the parish', declared that all the six people who made statements were living in Syderstone, had been known to them for years and were 'persons of veracity and good repute'. I have looked at the Syderstone records: Seppings and Savory were the two most important farmers in the parish and also served in official positions as churchwarden and overseer of the poor: most respectable men, then, and hardly likely to support a story of the paranormal without extremely good evidence.

29 June: long letter from Titlow. He was of the opinion that Spurgin and Stewart – who he admitted was persuaded that the noises heard were 'caused by supernatural agency, or by an evil spirit' – were 'suffering under the effects of a deception'. He suggested that the cause of the noises was a member of Stewart's family: this person could well have followed Spurgin to the remote part of the house and made the noises there as well. The feeble moans heard at the beginning of the evening came from Miss Stewart, who was 'much disturbed in a dream' while many of the noises were doubtless caused by rats. He refuted Spurgin's claim that at the end of the evening there had been four or six screams that were distinctly heard by everyone: he himself had heard just one, and that one could have been caused by a ventriloquist.

Titlow ridiculed the evidence of Elizabeth Goff, but he did point out that, if it was true, it showed that the ghost was not that of Mr Mantle, as some reports claimed: it had been present in the house even before the arrival of the Mantles: 'the good people of Syderstone, if hereafter they hear the terrible noise as of one walking in a silk gown, need not fear the approach of his departed spirit'.

13 July: Spurgin's response. Having furnished the public with the best information in my power as to the *facts* connected with the knockings and other noises heard [in Syderstone Parsonage] I feel but little inclination to trouble them with any observations on the *personal remarks* with which Mr Titlow has lately seen fit to notice my name. The impression on my own mind is that our different papers are all before the public, and that the public must now be left to form their own conclusions, both on the subject of which they treat, as well as the spirit in which they have been written.... I beg to assure Mr Titlow it is very far from my wish to interrupt him in the most extended exercise of his right of conscience and liberty of thought. This same privilege I ask at his hands for myself. In the question most under agitation, I desire not to influence the sentiments of any man. The whole matter is confessedly mysterious; and all that I have aimed to do in it, has been to place before the public some portion of the leading facts connected with this extraordinary case (as far at least as the nature of its peculiar

character would allow) in order that the public might have some ground of *judging for themselves* in coming to their own conclusion, whatever that conclusion might be: – but when I know that the *conjectures and insinuations* put forth by Mr Titlow have operated most powerfully both in my own immediate neighbourhood, as well as upon the mind of society at large, for the purpose of fixing upon Mr Stewart and the different members of his family the most odious imputations – I say, Sir, when I *know* such to have been the general impression made by Mr Titlow's letter as a whole, it is not the varied explanations he has given of many of its parts, that can ever make me consider that letter courteous or just. The very circumstance of Mr Titlow's having himself witnessed the noises in question, in Mr Stewart's house, he must have been aware would necessarily affix somewhat the stamp of authority to anything his imagination might have pleasure in indulging. It might also have been with Mr Titlow, matter for sober calculation how far *conjectures* put forth by himself in the present state of popular excitement might be converted by others into actual facts.... Had any decided act of imposition been at all discoverable, by either Mr Titlow or myself, we might have been at liberty to have published it; but when nothing of this kind could be seen (for Mr Titlow left Mr Stewart's house at least as much perplexed as any who were present), I think it was not the office of Christian love to put forth to the world conjectures which could not fail to involve a family of respectability in the most painful suspicions, and which might also serve to involve himself in the character of bearing false witness against an unoffending brother.

Spurgin went on to complain that Titlow had tried to destroy faith in the deponents by holding them up to scorn, and mocked them because of their humble circumstances. He says that Titlow's letter substantially confirms his own statements: 'Although it is true that he has raised a doubt on the *number of screams* which were heard, and as to the *absence of all the members* of Mr Stewart's family from one of the distant rooms, in which I heard the scratching on the wall, yet (without acknowledging the inaccuracy of my own former statements on these points) it is obvious they are points of very inferior consideration compared with the mass of mystery which has been brought forth to view. Mr Titlow has not, that I am aware, invalidated one single essential circumstance of my original statement, as it appeared in your paper of the 9th ult : *nor can he.*

Also letter, from James Overton of Sherford: 'the late communications to your paper respecting the (at present) mysterious noises at the Syderstone Parsonage having created a strong sensation in the minds of the credulous, I am induced to explain away the impression likely to be raised by the statement of Ofield, in your last week's paper. I perfectly well recollect the circumstance (being then a pupil of the then Mr Skrimshire) alluded to by Mr Ofield, and can assure you that those unaccountable noises were caused by one of the pupils overturning a table (in the drawer of which there were some leaden bullets) in the sleeping room. On the following day an investigation took place, and the pupil confessed the act, and was reprimanded. I beg to add, that I was a pupil at Mr Skrimshire's about five years, and during that time I never heard any noises which could not be accounted for.

20 July: We are requested to state that the letter from Mr James Overton of Thetford, which appeared in our last week's paper, has nothing whatever to do with the testimony of William Ofield. The circumstances to which the latter has referred in his declaration, happened during the *Holidays, when none but Mr Skrimshire's immediate family were in the house.* This explanation William Ofield desires to be made public, at the same time remarking, he thinks it very possible, at some time or other, such a proceeding as Mr Overton mentions, amidst the variety of noises heard in Syderstone Parsonage, may certainly have taken place.'

27 July: letter from Samuel Titlow. In my two letters respecting the evil spirit at Syderstone I have mentioned several facts, and it must be evident to the public that **not one** of those facts has been in the least degree invalidated. Previous to the hour of observation on the evening of May 15th, my thoughts were more contemplative and more serious than usual; I was expecting, from the detail of former disturbances, to be surprised with loud and violent knockings, and with other manifestations of a most extraordinary kind; but the noises having ceased, and my mind left to reflection, I felt a dissatisfaction even before I left the Parsonage, and a strong persuasion that the noises which had been heard during the night might be the effects of human contrivance. The gentleman with whom I conversed for five or ten minutes on the path which leads from the door of the house to the church knows what my apprehensions were even at that time; and the friend with whom I returned to Massingham cannot but recollect the earnestness with which I declared my conviction that, resting entirely and solely on the evidence afforded to my own senses, nothing had occurred in favour of a supernatural agency'.... It is not generally known by which of the parties concerned the names of the gentlemen present at Syderstone Parsonage on May 15th were given to Mr J Riches, who forwarded them to the public papers. To Mr Riches no blame can be imputed. I believe that on the morning of May 15th Mr Stewart was expecting only Mr and Mrs Spurgin to spend the night in his house: the rest of the company met by accident.

The editors of the Bury Post, in the paper of June 5th positively declared that 'the main facts of the noises, the vibrations and the impenetrable, were authenticated to them by one of the reverend gentlemen who sat up in the house'. And the editors of the John Bull newspaper, June 9th, stated that 'they had received a communication on the subject, declaratory, in confidence, of the writer's perfect conviction of the supernatural character of the disturbances created'. My name has been affixed to all my communications.

There the newspaper reports come to an end. However, Norman Fourdrinier has preserved among his papers, now in the Record Office copy of a letter written by Stewart from Syderstone Parsonage to his sister in Belfast on 30 March 1833. The letter was forwarded to him in 1957 by the then rector of Colby whose mother was helping an 'aged descendant' of Stewart's sister go through some papers.

In this parsonage lived thirty-six years ago the then curate, the Revd William Mantle. His wife, a remarkably fine woman, was Octavia Huntington, whose family of much

respectability resided near Hull in Yorkshire. He likewise was a Yorkshire man. They came to Syderstone from the curacy of Docking, a large village of small town about five miles distant. When first they arrived they were normal in their characters. They had a numerous family. Gradually they formed an intimacy with a very dissipated circle of gentlemen farmers around the place, which insensibly led them into vice. There was one of these named Temple who from an improper admiration of Mrs Mantle seduced the curate into the vilest debaucheries, so that latterly he was so much addicted to drunkenness as to go in that state to Church to perform the Divine Service. Ay, when performing the Burial service the bystanders were obliged to hold him by the elbows of his surplice lest he should fall into the grave upon top of the corpse. Well, he died in a miserable state, and before his coffin was removed for interment, strange noises began to be heard in the Parsonage. The Revd Mr Evatt succeeded Mr Mantle, and his shade [Mantle's] has been seen, it is averred, twice distinctly, the latter time in his silk gown. Most violent noises have been heard repeatedly during the entire period since, but only at long intervals. The last curate, Mr Skrimshire, as well as his predecessor Mr Evatt knew this. All the parish almost had long known it, but not one could be found to make us uneasy by hinting that any such occurrence had ever been known. We had resided in the Parsonage for eleven moths before it seemed the will of God to make us know it.

Ever since the beginning of this month my clever little girl had been complaining when we met at breakfast that she had heard so many hours strike on the clock on such a night, and such a night. At length she firmly declared she knew not why, but she could not sleep. We tried to laugh her out of it. However, becoming more and more wakeful she at length heard plainly a loud knocking on the wall of the room within hers (and where the two maid-servants slept) – the door between my little girl's room and theirs being always kept open. She called to the servants repeatedly before she could so far awake them as to enable them to hear it. They became greatly alarmed. 'Well' said the heroic child, 'I'll secure the bolt at the foot of the back stairs (off the landing of which the two rooms run). I'll go and bolt it since you two great women are so frightened as not to be able to move from your bed'. Saying this, and in the midst of all the most awful knockings she —— to the bottom of the stairs and shot the bolt.

Next night, the 8th, the knocking was renewed, and the maids who were actually incapable of motion persuaded my little dear to ascend the passage to her brothers' room and awake William and John. We had desired to be called. I arose at 2 o'clock, heard it and proceeded down to the kitchen and passages and cellars underneath, and examined most perseveringly every spot there was. There could have been no human agency. The knocking stopped the instant I set my foot on the stairs going down to examine. I stopped a minute on my return, all continued silent. I went to bed. Before I had time to sleep – we were called upon – the noises, louder and more continued. Mrs Stewart would go this time and refused to suffer me. This was 3 o'clock. She remained away until near 5. The loud, hollow unearthly tones that were given by the struck wall I cannot describe. Speak to it and it will give you whatever number of strokes you name. This was on the Sabbath morning. All was quiet that night – until Monday. Monday night these frightful noises returned. Next night, Tuesday, Mrs Stewart and

I, having first removed the children and servants into the centre of the house from the North wing, resolved to sit up and watch.'

The later developments we know from the newspaper accounts already quoted. Foudrinier formed his own opinions as to the case: 'In a final letter Mr Titlow re-affirmed that the noises were clearly not supernatural in origin as Mr Stewart maintained. He seems to have suspected a hoax by some members of Mr Stewart's household, but I think that an ordinary person reading the account of the noises today in full would come to the conclusion that they were an accurate description of the noises made by rats, in spite of the fact that Mr Spurgin in a final letter distained such a suggestion. However, Mr Spurgin said that for the first ten months of his residence at Syderstone Mr Stewart was not disturbed by any noises at all and that his predecessor, Mr Skrimshire, who kept a school or took pupils, was often twelve months or more without hearing these noises. Of course a sudden infestation as described there is typical of rats.'

Signed by N. D. Foudrinier.

Foudrinier explains a couple of otherwise puzzling points. After Mantle's death, the Parsonage was divided into tenements, which explains the statements of the deponents who had been living in part of it: it became one house again in the 1820s when Thomas Skrimshire used the rooms which had been previously rented out as a school. Stewart originally invited four adults to listen out for the sounds – John Spurgin, vicar of Docking and his wife, Mr Goggs, the vicar of South Creake, and Mr Bankes, a surgeon of Holt. Mr Lloyd, the rector of Massingham, happened to call by that afternoon, bringing with him Mr Titlow, vicar of St John Timberhill in Norwich, and they were invited to stay the night and listen. Perhaps it was because he came from Norwich that Titlow more sceptical than four country clergyman, the wives of two of them, and a local doctor. His letters suggested that he suspected a member of the family of faking the noises: however, according to Foudrinier, Stewart's two boys were eight and ten at the time of the haunting, rather young to have successfully deceived such an august band of adults.

The impression given is that the ghost was that of Mantle but Elizabeth Goff makes clear that the house was already haunted in Mantle's time. Is there another candidate for the ghost? I think that there is. Arthur Mee writes about Syderstone: 'In the grounds of the rectory stood Syderstone Hall, home of Sir John Robsart, sheriff of Norfolk and Suffolk. Here in fancy we may picture the slender figure of his daughter [Amy Robsart] flitting among the trees and on the lawns. It seems most likely that she first saw Robert Dudley, Earl of Leicester, when, as a member of the expedition to quell Kett's Rebellion, he stopped at Sir John's later house, Stanfield Hall near Wymondham, but from letters still preserved we judge that after her marriage she came back here to live for a time, finding here some brief happiness in the years of distracted life which ended so tragically at Cunmor.... Her initials A R are on the churchyard gate, and over the entrance to the Norman tower, reached by a sunken path between rocky walls strewn with flowers, is Robert Dudley's badge carved in stone.'

This and next page: Amy Robsart is still fondly remembered in Syderstone

The tragic story of the life and death of Amy Robsart belongs to the history of England. She married Lord Dudley, but it was not a happy marriage and they lived most of their lives in different houses. Meanwhile Dudley became a great favourite of Queen Elizabeth I: there were rumours throughout Europe that the couple would marry if only Amy were out of the way – and even that Dudley was intending to poison his wife! In September 1560, Amy was found dead at the bottom of the stairs at Cunmor House, one of the many properties owned by Dudley. Her neck was broken: had she fallen or was she pushed? An Inquest gave the cause as an accident, but rumours continued to surround the affair. Had Dudley, who was not in the house at the time, arranged it? Perhaps he had succeeded in poisoning her, and had had her neck broken after death to give the impression of an accident? Perhaps, alone and unloved, Amy had herself decided to end her life? The rumours of scandal were so strong that any question of marriage between the Queen and Dudley was impossible.

Syderstone today is proud of its association with Amy Robsart: her initials, seen by Mee, are still on the churchyard gates and the village hall is named after her. Perhaps it is the figure of Amy Robsart that haunts Syderstone Parsonage, the site of probably the few happy days in her short life.

REFERENCES AND ACKNOWLEDGEMENTS

I have tried to use as many examples of paranormal experience as possible from archive material held at the Norfolk Record Office, whose collections make up an incredibly rich source for this, as for all aspects of Norfolk's heritage. Chapter 8 is entirely devoted to the works of W. H. Cooke (MS 4311; COL 8/81; HMN 7/322). Other collections of material relating to the paranormal and to folklore include those of Anthony Hamond (HMN 6/210-221,225,226), W. G. Clarke (MS 122); and Mark Taylor (MS 4322, 4412, 4413). Individual stories among the archives include Norman Fourdrinier's work on the Syderstone ghost (MC 5/6,16), the story of Mr Booty on Stromboli (NCR 9g), the Lynn All Saints skeleton (PD 607/94), the story recorded in the Gateley parish register (PD 9/1) and the Yarmouth mummy (Y/ED/S/107a). References to Polidori are from the journal of J. G. Crosse (MS 470). The cuttings in the documents supporting the Norfolk Sound Archive are AUD 1/1/217

Many of the illustrations are also from the collections of the Norfolk Record Office: I am grateful to the County Archivist, Dr John Alban, for permission to use these images. Their references are:

19: MS 7239
25, 63, 64: ACC 2010/4
26: MC 2105/1/5
31: BOL 4/34
32 bottom: MC 365/34
39: MS 4322
42: C/S 3/41a

48: N/LM 2/12
52: Y/TC 86/12/64
56, 57: MC 376/287
74: MS 4576
75, 77, 79 top: COL 8/81
76, 79 bottom, 80, 86: MS 4311
82, 84: HMN 7/322

Images on pages 56 and 57 are from the collections of the United States Army Air Force at the Record Office: I am grateful to the American Memorial Library in Norwich for allowing me to use these photographs.

ALSO AVAILABLE FROM
AMBERLEY PUBLISHING

Norwich Through Time
Frank Meeres

Price: £14.99
ISBN: 978-1-84868-458-4
Binding: PB
Extent: 96 pages
Full colour throughout

Available from all good bookshops or order direct
from our website www.amberleybooks.com

ALSO AVAILABLE FROM
AMBERLEY PUBLISHING

Thetford & Breckland
Through Time

Frank Meeres

Price: £14.99
ISBN: 978-1-84868-453-9
Binding: PB
Extent: 96 pages
Full colour throughout